110838834

BARRON'S ART HANDBOOKS

HUMAN FIGURES IN MOVEMENT

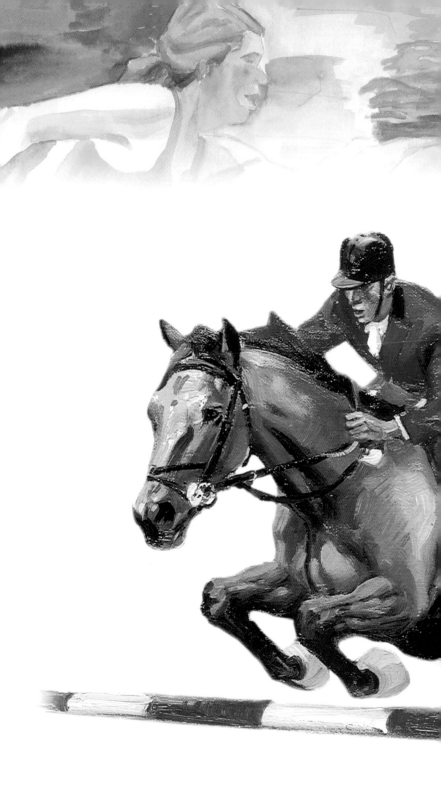

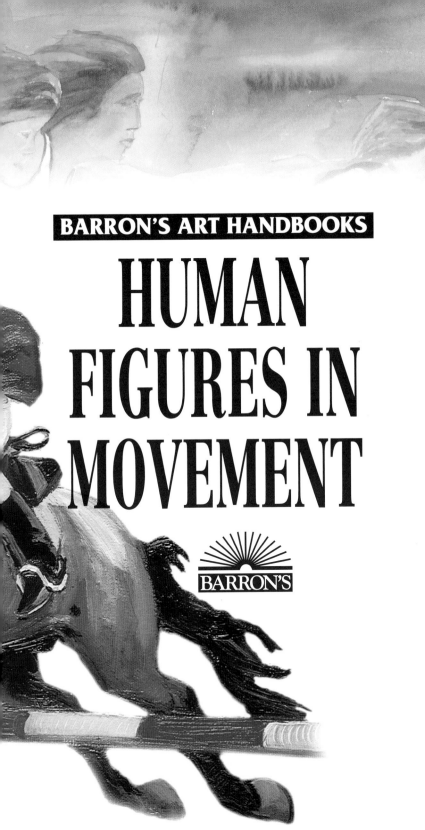

BARRON'S ART HANDBOOKS

HUMAN FIGURES IN MOVEMENT

BARRON'S

CONTENTS

CONTENTS

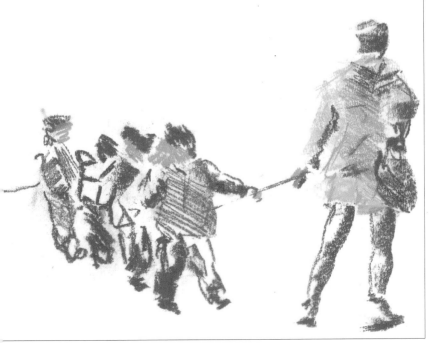

THE FIGURE IN MOTION

The figure in motion is the most significant challenge for artists,
since the drawing has to be done from memory, and a lot of work
with the palette is required to convey imagined flesh tones.

Drawing

How should we go about depicting a figure in motion? We first have to construct a sketch to act as a guideline in applying the colors. The most important line of the sketch is the one that defines the profile of the figure; to that we add the lines that delineate the shapes within the figures. A thorough knowledge of perspective is required in drawing foreshortening in a cohesive manner.

Anatomy

Concepts of human anatomy concerning the skeleton and muscles enter into creating

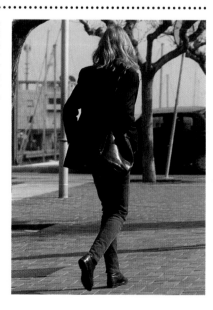

In order to draw or paint a figure in motion, like this young person walking, you first have to do a sketch.

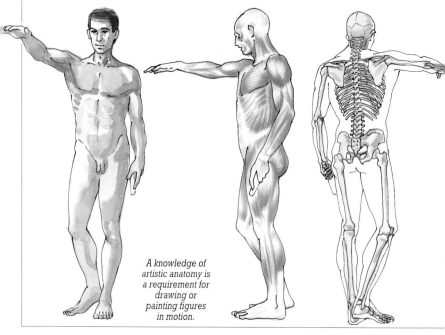

A knowledge of artistic anatomy is a requirement for drawing or painting figures in motion.

Dürer, among other painters, established the ideal canon.

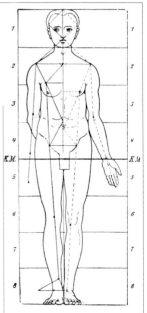

a drawing, and approaching these issues should help resolve any pictorial problems. It's interesting to consider what comes into play when a movement is carried out.

The Canon

Since ancient times, artists have been interested in portraying humans in movement through statues and paintings. Studies of the great masters, who had a profound knowledge of the human figure, established the canons, that is, the theoretical guidelines to follow. In order to draw or paint a figure in motion, we have to rely on these guidelines for the proper proportions.

The canon is established based on a male, female, or juvenile figure, seen from the front, the back, or in profile, and obviously in a static position.

Although there are several canons, the one most commonly used in drawing and painting involves eight heads for an adult man or woman. The proportions between all the parts of an individual's body are established according to that canon.

Movement

Movement implies action in which a person passes from one position to another by using various muscles and placing all the limbs in the positions necessary to carry it out: flexion in one arm or a knee, inclination of the head, a twist in the torso, and so forth. A lot of practice is required to portray the action convincingly.

It's not possible to deal with movement without mastering the human figure in static positions, complicated foreshortening, and doing quick sketches.

Drawing and Color

Color is applied by any chosen method—oils, watercolors, acrylics, pastels, and so forth—using as a guide an accurate profile of the figure in motion. The uncolored silhouette doesn't communicate shape. In adding color, we have to be attentive to the muscles and their location, and they have to be depicted according to the color values and tones that the living model has.

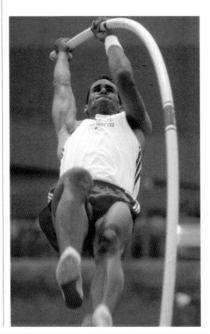

This athlete is calling his entire locomotive apparatus into action in a complex coordination of effort.

ANATOMY OF THE HUMAN BODY

Muscles and tendons in action give a figure body; they cover the skeleton, whose structure is visible in all parts of the body that are not covered by muscle. Also, the tensions and wrinkles of the clothing respond to the action being carried out.

The Skeleton

Artists need to have a knowledge of the human skeleton that allows them to observe more effectively and learn about figures in motion.

Even though the skeleton is entirely covered, there are areas where it can be seen and even felt. When a figure is observed in a static position or in motion, we have to try to perceive the bones of the hips, the knees, the elbows, the tibias, the clavicles, the cheekbones, the spinal hypophysis, and so forth. When we draw or paint slender or muscular people, it's easier to locate these elements than in huskier people.

Muscles and Tendons

Given the complexity of the human body, several muscles and tendons are activated to carry out even a simple movement. Thanks to the workings of the muscles and tendons, people can move all the joints of their skeletal structure.

Some muscles and tendons are of great importance to artists. A knowledge of anatomy is important to artists who need to know where to situate any protuberances.

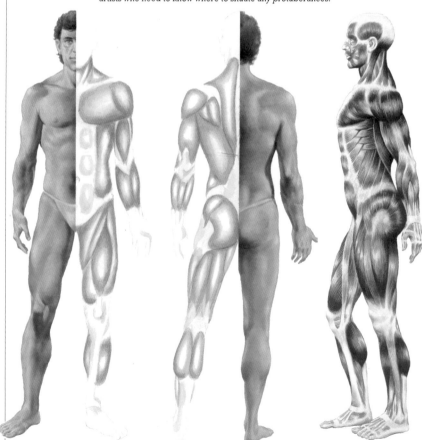

The Human Head

The face muscles are responsible for creating expressions. Exertion, concentration, shouting, despair, and other factors move or call one or more muscles into action at the same time. Observation of any part of the body by the artist is essential, because its movement has to be expressed convincingly; just the same, the difficulty is even greater in the case of facial features, since you don't want to depict a grimace or other inappropriate distortion.

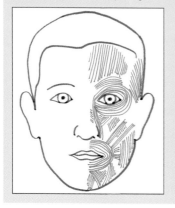

These are the most important muscles that produce facial expressions.

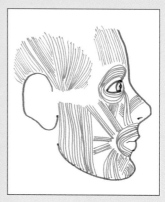

Not all muscles are equally important to artists. For the purposes of art, it is indispensable to know the most important muscles, for they increase in size and shorten when the body is in motion. In general, tendons stand out when they are under tension. So it is important to consider the position of the various parts of the body in a movement that calls joints, muscles, and tendons into action.

Artists must be capable of locating the most important muscles in a body seen from the front, from the side, and from the rear. Of course, a woman, a man, an old person, and a child are fundamentally different, and each is approached with a view to the individual nature of the model.

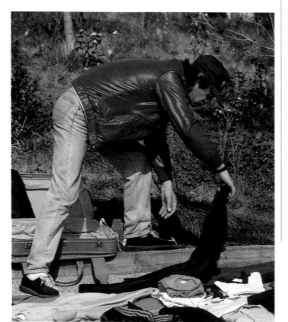

MORE ON THIS TOPIC

- The Physical Expression of Exertion **p. 48**
- Muscles in Action **p. 50**
- Sports **p. 76**

Muscles from the entire body come into play in figures in motion. We can observe their action by analyzing the tensions revealed in the clothing.

THE THREE CANONS

It is a basic requirement to become familiar with the proportions among the different parts of the human body. The existence of an ideal canon is a very useful element in art, regardless of the differences that exist between one person and another.

The Canon

Since antiquity, artists have been concerned with creating a model for the proportions of the human body. There are several canons that pertain to adults: one for an average figure, one for a heroic figure, and one for the ideal figure. The height of the head is used as the basis for the study of proportions; it is the unit of measure.

The Canon for the Average Figure

For a person of average constitution, the canon of

The Individual Canon

The canon for the ideal figure based on eight heads is not appropriate for all cases; for example, in some cases the arms or the legs are shorter. When the individual features of a person affect the size of the head because they are larger or smaller, we have to modify the entire canon. In the case of people who are muscular, stocky, or obese, their total width is adjusted, and their true proportions with respect to the height of their heads has to be established.

seven and a half heads is used. In this case, the total height of the individual is seven and a half times the height of the head, and the width of the body is two heads.

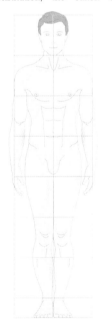

Here is the canon of seven and a half heads for an average figure.

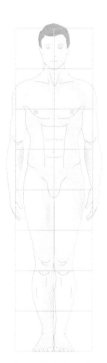

For an ideal figure the canon of eight heads is used.

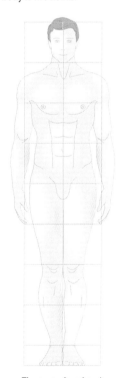

The canon for a heroic figure is eight and a half heads.

The Canon for the Ideal Figure

The ideal figure is commonly seen as more perfect than average: a little taller, slender, and well shaped. The canon for the ideal figure is eight heads, and it is commonly used in drawing or painting figures in motion. The total width amounts to a little more than two heads, but without approaching the breadth of the one for the heroic canon.

The Canon for the Heroic Figure

Heroes tend to have a very strong constitution; they are tall and muscular, and the best canon for them involves eight and a half heads. The total width of a very muscular person exceeds two heads.

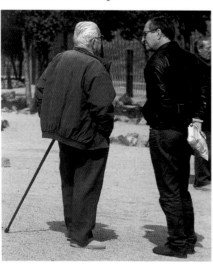

You can apply the most appropriate canon with a simple sketch—eight heads in this case. To do the sketch, the main thing is the proportion between height and breadth, which is different for every figure, plus the direction of the hips and the back.

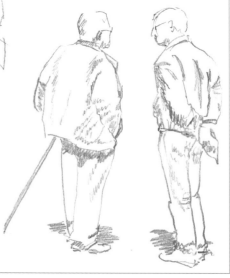

MORE ON THIS TOPIC

THE MALE FIGURE

A series of very useful distances and reference points can be established using the canon of eight heads with a male figure. Based on this canon, it is easy to situate the nipples, the navel, and the knees.

Eight Heads Tall

The height of the head is the unit of measure used in the canon. How are the different parts of the male body proportioned according to the eight heads? In order to locate the most important points, a grid that embodies the canon can prove very useful. Once you have settled on the size of the head, it occupies the highest section of the grid, and that measurement is repeated eight times. The most important points are easily located on that total height. Starting with the head and going down to the feet, count two units to locate the nipples, three for the navel and the height of the elbows, and four for the pubis, which is located in the middle. Count up two units from the bottom to locate the knees.

Two Heads Wide

For all figures, whether seen from the front or the rear, there are some issues that must be addressed when using the eight-head canon. The breadth of the shoulders is slightly greater than two

Here are the reference points and the proportions for a male figure according to the canon of eight heads when seen from the front, the side, and the rear.

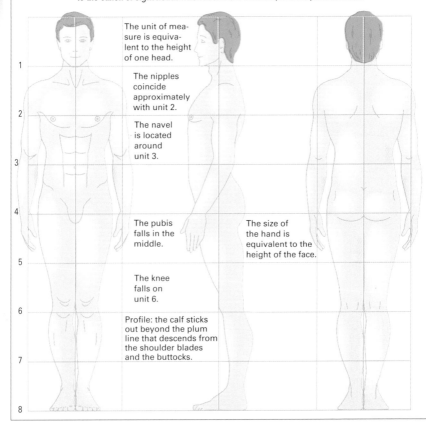

The unit of measure is equivalent to the height of one head.

The nipples coincide approximately with unit 2.

The navel is located around unit 3.

The pubis falls in the middle.

The size of the hand is equivalent to the height of the face.

The knee falls on unit 6.

Profile: the calf sticks out beyond the plum line that descends from the shoulder blades and the buttocks.

Profile

Creating the profile or silhouette of a figure involves the first approximation of the drawing. The medium for the sketch depends on the one chosen for the drawing or painting. When you use the canon as a guide, there are scarcely any problems in drawing the human body.

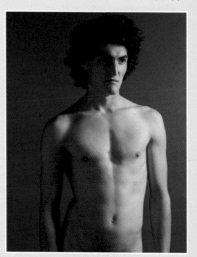
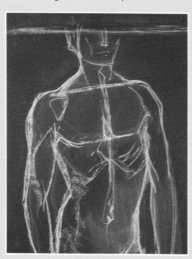

A sketch based on a model is done on paper using a pastel color—the same medium to be used in the painting.

heads, and the width of the rest of the body is a little less than that distance.

The hips are the part of male anatomy that display the greatest breadth, after the shoulders. If the pubis is located in the very center of the canon, in the side or rear view, the bottom of the buttocks is lower.

Hands and Feet

According to the canon, the hand is as long as the face, or a

The ideal canon of eight heads indicates that the length of an adult hand is equivalent to the height of the face.

little less than one unit. This is a very important factor that has to be taken into account when dealing with the human body.

The breadth of the sole of the foot, seen from the front, is half a unit.

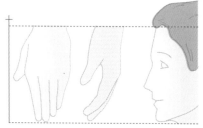

Seen from the side, the foot exceeds one unit in length.

The width of the foot, as seen from the front or the rear, is half a unit of measurement; in profile the foot is slightly more than one unit.

Even though the size of the hands and feet varies quite a bit among individuals, the canon is still a very useful reference point.

MORE ON THIS TOPIC

- The Three Canons **p. 10**
- The Female Figure **p. 14**
- Frontal View **p. 20**

THE FEMALE FIGURE

The ideal canon of eight heads is also used for female figures: the female attributes are easily situated according to this representational theory. In dealing with a real female model, it will be necessary to individualize the guidelines of the canon to use them for reference.

Eight by Two

The height of the female head is the unit of measurement for the canon. Eight times the height of the head yields the total height of the figure; the width is represented by two heads.

The ideal canon of eight heads situates the pubis in the center of the representation. The top of the head and the soles of the feet are equidistant from that point. The knees are located halfway between the pubis and the sole of the feet. The line of the clavicle is less than half a unit from the chin, and the height of the elbows is one unit above the pubis.

MORE ON THIS TOPIC
• Comparative Morphology **p. 18**

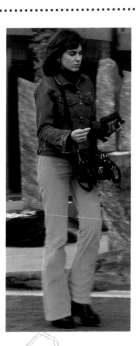

The ideal canon of eight heads for a female figure highlights very important reference points among the various proportions of the body parts.

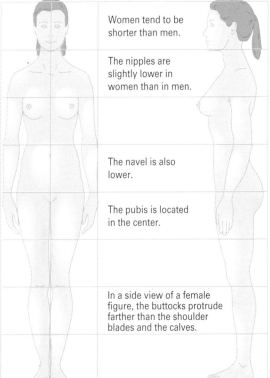

Women tend to be shorter than men.

The nipples are slightly lower in women than in men.

The navel is also lower.

The pubis is located in the center.

In a side view of a female figure, the buttocks protrude farther than the shoulder blades and the calves.

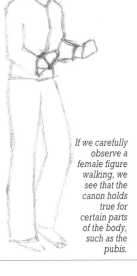

If we carefully observe a female figure walking, we see that the canon holds true for certain parts of the body, such as the pubis.

Nipples and Navel

The navel is located slightly lower than unit three (by about a third of a unit), and the height of the nipples is slightly below the second unit.

Breasts and Buttocks

The most salient parts of the female figure as seen in profile are the breasts and the buttocks. It is clear that the forms of the breasts and the buttocks are idealized in the canon, and they will have to be individualized in drawing a female figure in a static pose or in motion.

Sketching the Female Figure

A walking girl directs all her movements toward carrying out the action, and the most representative sketch has to be isolated at any moment.

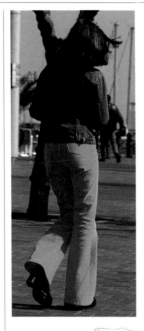

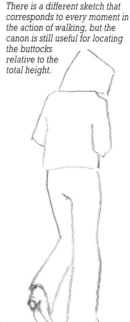

There is a different sketch that corresponds to every moment in the action of walking, but the canon is still useful for locating the buttocks relative to the total height.

By using just a few straight lines, the different parts of the body can be located in their proper positions in accordance with the appropriate foreshortening.

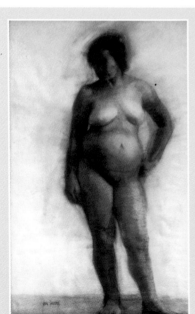

The Pubis and the Center

According to the canon for the ideal figure, the pubis is located in the center of the representation. A head that is slightly smaller than average can't be used as a unit for counting units. Longer or shorter legs than the ones represented in the ideal canon also require modifications, since the proportions among the various parts of the female body in question are not guided by the canon.

The canon for the ideal figure, with the pubis located in the center, is therefore a theoretical, working instrument that must be corroborated by reality; we have to measure and observe the characteristics of the figure serving as a model.

Charcoal drawing by Joan Sabater of a female figure that requires measuring, since the ideal canon doesn't apply to it.

THE CANON AND AGE

The canon of eight heads applies to adult individuals, but for babies, children, and adolescents, we have to be guided by canons of five, six, and seven heads, respectively, since as people grow older, the height of the head diminishes in proportion to the rest of the body.

Children at the Age of Two

Up to 2 years of age, children have a very large head in proportion to the rest of their body. In this case, the canon of five heads is ideal. The navel is located in the center. The pubis is located at unit three, and the level of the knees is a little above unit four. The width of the face, seen from the front or the back, is less than two units.

Seen from the side, the belly protrudes, and the most prominent part in the rear is the back of the skull.

The technique for depicting babies and children under age

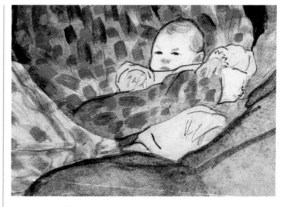

Anna Sicart has captured the characteristic movement in this baby's gesture.

2 is the following: large head, short and chubby legs and arms, and prominent belly. The smaller the child, the more pronounced these characteristics are.

MORE ON THIS TOPIC

- The Figure in Motion **p. 6**
- Comparative Morphology **p. 18**
- Quick Sketches **p. 56**

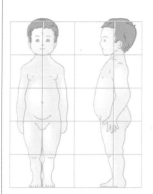

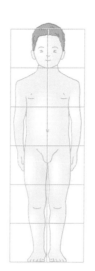

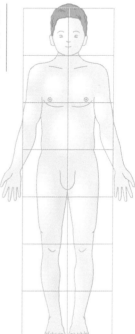

The canon of five heads corresponds to a child at age 2; six heads applies to a 6-year-old child; and seven heads is appropriate to a 12-year-old.

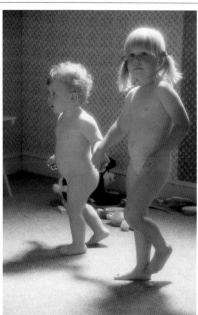

Let's carefully observe the features of these two different ages.

nipples is located by counting two units from the top of the head. Three units apply to the location of the navel; the pubis is at the fourth, and the knees are nearly on the fifth.

The width of the figure of a 12-year-old boy is two units.

The Canon and Static Poses

Babies and small children are quite motionless when they are asleep. If you want to draw or paint from real life rather than using a photograph as a model, you should begin practicing with a sleeping baby or child. Even though they may move when they sleep, there is always some pose that is held for several minutes, making it possible to use the canon for reference.

Six-year-old Children

Children experience a growth spurt up to age 6, and the proportion between the head and the rest of the body changes. The canon of six heads applies to this age. The legs and arms grow longer, and the child loses the round-ness that goes along with the canon of five heads.

Between the navel and the pubis there is slightly less than one unit. These features are equidistant from the center of the representation, and the knees are located in the middle of the second unit as you count downward.

The width of a 6-year-old child's figure, as seen from the front or the rear, is scarcely two modules.

Adolescents

In puberty, the figure be-comes even more slender, and the most appropriate canon is the one that uses seven heads. The height of the

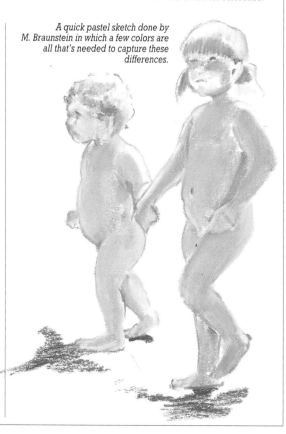

A quick pastel sketch done by M. Braunstein in which a few colors are all that's needed to capture these differences.

COMPARATIVE MORPHOLOGY

Women tend to be shorter than men. In addition, the location of different masculine and feminine reference points is different. The eight-head canon is used for both figures, but it is adapted to the requirements of the two sexes.

The Canon of Eight Heads

The head of a woman is commonly smaller than a man's. As a result, when the canon of eight heads is applied to a woman, she turns out smaller than a man.

Other noteworthy differences must be kept in mind in locating two essential features. The height of a female's nipples is significantly below the second unit. A woman's navel is also located lower than that of a man, below the third unit from the top.

The line of the clavicle is higher in men than in women. Thus, the ideal male figure appears more square than a female figure when viewed from the back.

Hands and Feet

The length of the feet is one of several important features. In adulthood, a man's foot is somewhat larger than a woman's. The length of a man's or a woman's hand is represented by the length of the face. However, the proportions are clearly different in babies and children. A baby's hands and feet are very small in relation to the face. The length of the hand and foot of a 2-year-old child is about half the unit. As a child grows, the hands and feet develop to exceed the length of the face, until the adult proportions are reached in adolescence.

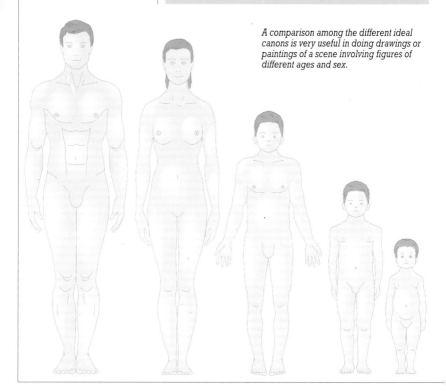

A comparison among the different ideal canons is very useful in doing drawings or paintings of a scene involving figures of different ages and sex.

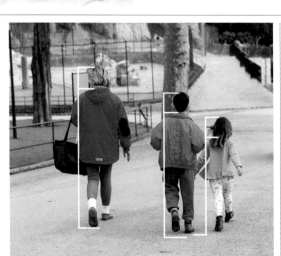

It's interesting to note the proportion between the size of each head and the corresponding height.

MORE ON THIS TOPIC
- The Three Canons **p. 10**
- The Male Figure **p. 12**
- The Female Figure **p. 14**
- The Canon and Age **p. 16**

And the last major element is the shape of the chest.

Comparison with Other Ideal Canons

When models of both sexes and different ages are used in the same representation, we have to use canons of five, six, seven, and eight heads. It is important to maintain the correct proportions in each case if we want the picture to appear lifelike: a 5-year-old child, for example, can't be illustrated using a canon of eight heads.

In a profile view, the buttocks of a female figure project farther than the calves and the shoulder blades; the most salient feature of a male figure is the calves.

With respect to width, men are generally broader than women.

Another important comparative element is the different curvature at the waist.

All the proportions of both figures are interrelated, and this has to be captured in the sketch (in charcoal, done in this case on an imprinted fabric for painting in oils).

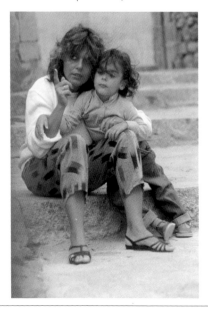

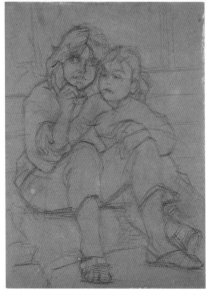

FRONTAL VIEW

A figure in motion can assume very different positions. The canon helps in studying such figures. It is also useful in analyzing the distribution of symmetrical features of human morphology that are readily visible from the front, relative to the principal line of movement.

Symmetry

Represented in a frontal view on a flat plane, the human body presents a number of obvious correspondences and symmetries. For this type of analysis, the most significant line is the one that divides the human figure, viewed from the front, into two parts as it passes through the nose, the navel, and the pubis; in a rear view, the line follows the spinal column. A frontal view of men, women, and children has many symmetrical features with respect to this line. In the face, for example, there are the eyes, the eyebrows, the eyelashes, the cheeks, the nostrils, the lips, the corners of

In this position, the vertical line that passes through the center of the female figure seen from the rear is very important.

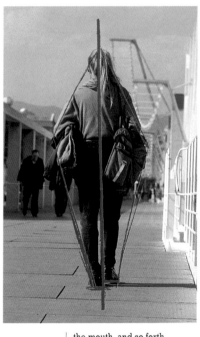

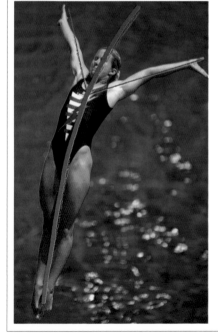

In this instance, the most important line is the curve described by the arching body.

the mouth, and so forth.

The structure of the right arm is a mirror image of the left. Similarly, the right leg corresponds to the left, and one side of the chest to the other.

In the back, on both sides of the vertical line that passes through the center of the back and between the buttocks, there is symmetry in the shoulders, the shoulder blades, the hips, and the buttocks, among others.

The existence of all these correlations facilitates analysis in depicting a figure in motion.

MORE ON THIS TOPIC

- Profile **p. 22**
- Natural Posture **p. 24**

The harmonious arching of the body is represented by a curved line; on either side there are crucial points or directions, such as the height of the hip bones or the nipples.

are isolated. Where there is no postural symmetry, the movement is analyzed comparatively by highlighting opposing positions. In running, for example, when the right leg is moved forward, the left remains behind; but the corresponding movement in the arms involves leading with the left one and trailing with the right.

Significant Elements

There are many figures in motion in which the symmetrical features of human morphology maintain their position. Others adopt postures in which the symmetry is morphological, but not positional. Whenever the action permits it, the features that maintain postural symmetry

Although it's easier to deal with frontal views of figures, it still takes a lot of practice to produce a sketch with the mastery displayed in this one by Vincenç Ballestar.

Facial Features

A male or female face seen from the front is represented as two and a half units wide and three and a half units high; the module of proportions is the height of the forehead. The frontal view of a face can be divided into five vertical divisions, the measure of which is the breadth of the eye. Starting at the bottom, the lower part of the mouth is located in the middle of the first module; the lower extremity of the nose and ears begins at the dividing line for the second module; the upper part of the ears coincides with the ciliary arch, located two modules up from the chin; and the height of the eyes is determined by drawing a horizontal line halfway along one of the vertical divisions.

The symmetry in the facial features breaks down when the expression uses muscles on only one side of the face.

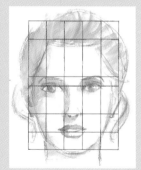

If the module is the height of the forehead, a head is three and a half modules high and two and a half wide.

PROFILE

With a figure in motion seen from the side, it is important to locate the line that defines the direction of the torso. The guidelines of the canon make it fairly easy to locate the head and the torso, and the rest of the figure is studied, compared, and measured in the artist's manner.

Silhouette

In order to draw a figure in motion seen in profile, the silhouette has to be drawn. A swimmer about to dive, seen in profile, is a very simple model, since one arm and one leg aren't even visible behind the nearer limbs in extension (the arm) or flexion (the leg).

In a running figure, the movement is examined in accordance with the human body's characteristics of locomotion.

The movement in the right arm is associated with that of the left leg, and vice versa.

A simple theoretical sketch helps to capture the reciprocity between the movements.

A part of the body is visible in profile, and that always makes the work easier.

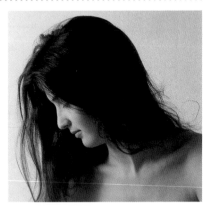

MORE ON THIS TOPIC

- Frontal View **p. 20**
- Natural Posture **p. 24**
- Foreshortening **p. 26**

Salient Features

The most salient features in men are the buttocks, and the breasts and the buttocks in female figures. If they're not

The silhouette of a figure in motion seen from the side, as in this case, is fairly easy to construct.

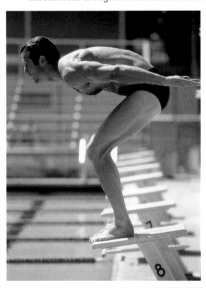

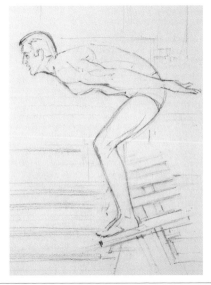

placed accurately, they imme-
diately create an impression of
distortion.

A moving figure seen in
profile exhibits activity in the
shoulders and displacement in
the hips. Any kind of sketch
can be used to clarify the
posture of the body. These
sketches are very useful in
immediately locating the most
prominent areas.

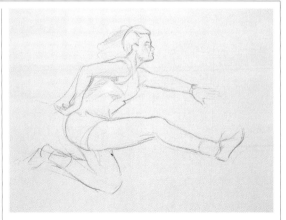

*Using the sketch as a guide, the representation of the figure can be
colored in, with watercolors in this case.*

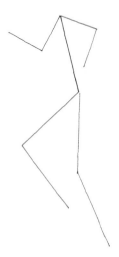

*In running or jumping, there is
an inverse relationship between
the left and right upper and
lower limbs.*

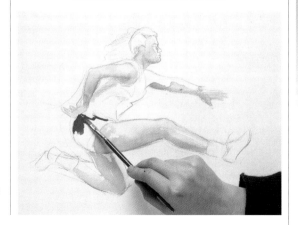

The Head

When seen in profile, the head is one of the simplest features to draw. In depicting the silhouette
of the head, we keep in mind the proportional arrangement of the ideal canon. The height of the
male or female head, seen in profile, is three and a half times the height of the forehead. The
height of the face is three times that of the forehead. The lower edge of the nose and the ear
coincides with the second module from the bottom. The
height of the ciliary arch and the upper part of the ear
coincides with the third module. The lower part of the mouth
coincides with the middle of the first module from the
bottom. In a face turned to the left, the ear is located on the
third vertical module from the left and at the height of
the second module from the bottom. The width of the head
is three and a half modules. How do we situate the eye?
Divide the corresponding module into three parts; the center
of the eye is located at the junction of the dividing lines
indicated in the adjacent drawing.

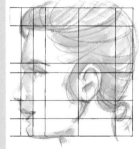

*Seen from the side, the head is three and a half modules
wide and three and a half high. The module is the height
of the forehead.*

THE CANON AND FORESHORTENING

NATURAL POSTURE

For the study of a figure in motion, we use all the knowledge about human morphology, and the proportions of the most appropriate canon for the figure. The drawing needs to capture the naturalness of a slight, moderate, or strenuous movement.

Static Figures

Before working on moving figures, you have to practice with figures in static poses. With these models you use the canon, draw some simple sketches, and take measurements in the artist's manner; the sketches must first express the gesture. With patience and many hours of practice doing quick sketches, you can make progress with static figures and the many poses they can assume.

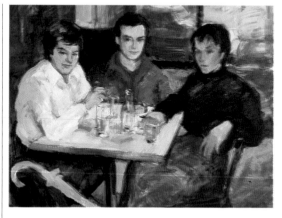

You have to practice with scenes that are easy to work on, such as static figures involving minor movements.

Figures in Motion

A figure in motion is infinitely more complex: the movement indicates that the figure is not stationary. How can we draw or paint it in these circumstances? There are several ways to go about it. One way is to use a photograph. Another is to practice with an articulated mannequin. A third is to memorize what we observe directly in the moving figure.

Eventually you will be able to do a quick pencil sketch of a person walking, even at a fast pace. You need to develop your visual memory.

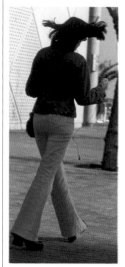
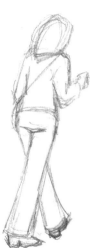
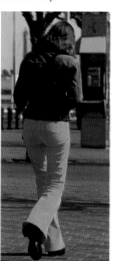
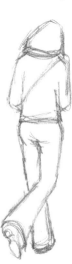

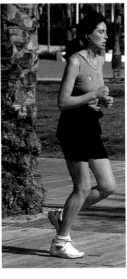

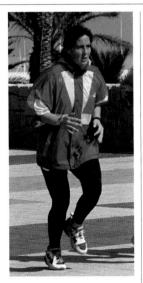

With practice, you establish analogies between figures through the distribution of some of their parts. Any type of analysis is helpful.

Types of Movement

By observing figures in action, it becomes possible to speak of slight, moderate, and strenuous movements. The difficulty in drawing varies as a function of the effort expended by the person doing the action. We have to differentiate between a static pose and one that suggests movement. Even the most common movements can put several features into action; the issue is observing them carefully, because each of them is a separate case. A person can perform multiple movements: standing, using a spoon to stir the contents of a pot cooking on a stove, looking for coins in a change purse, walking, sitting, reaching for a book on a table, bending down to pick up a newspaper on the ground, rolling over in bed, running, jumping, to name a few.

The naturalness of movement in this group has to be part of both figures.

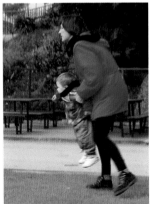

Credibility

Naturalness in the expression of movement is one of the bases for credibility in a drawing. Spontaneity is sustained by an exhaustive analysis of proportions that suffices for the foreshortening presented by the moving figure. Still, the only way to capture freshness is by mastering the techniques of the medium used for the depiction, whether it is oils, watercolors, or acrylics.

Like pencils, markers make it possible to do quick sketches, but since they allow the addition of color, they provide more information.

FORESHORTENING

When we speak of canons, we are dealing with figures in static positions, maintaining as much symmetry as possible. However, artists can have a point of view on a moving figure that results in a different foreshortening in every part of the body.

The Horizon Line

Studies in perspective are very useful in resolving the foreshortening of the human figure in motion. First of all, we have to locate the horizon line. It is located in front of the artist who is observing the moving figure, and it is the horizontal line that cuts between the horizontal plane that passes at eye level, and the vertical plane situated in infinity.

Point of View

Once the horizon line has been located, it is necessary to determine the artist's point of view of the moving figure. The point of view (which must be located on the horizon line) is right in front of the artist who is looking at the model.

In very simple cases involving a frontal view, the general perspective on the

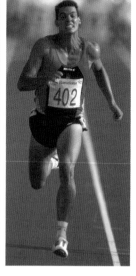

The point of view and the vanishing point coincide in this instance.

moving figure is a parallel one, and the only vanishing point that exists is also the point of view.

With oblique or aerial perspectives, the point of view does not coincide with the vanishing points.

Perspective

We have to find some simple box to fit the entire figure into. The projection of this box in the perspective that corresponds to the point of view creates a sense of how to equate the proportions of the figure to its position: larger, nearer; smaller, farther. This issue is treated in greater detail on page 32.

Projected Shadows

Shadows are a very important pictorial element in representing bodies in movement, whether in an open space with natural light or in a closed space with artificial light. The shadow that the figure casts onto the surface that supports it, or over which it is suspended, responds to perspective in relation to the light source.

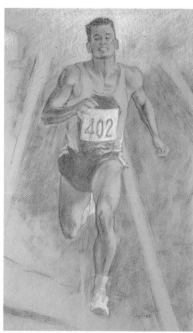

The definition in this drawing in sanguine by Josep Torres is a direct application of the norm: larger, nearer; smaller, farther.

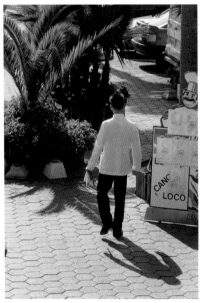

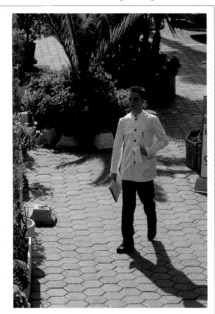

Let's look at the effect of different perspectives on a waiter. From left to right and top to bottom, they correspond to parallel, oblique, and aerial.

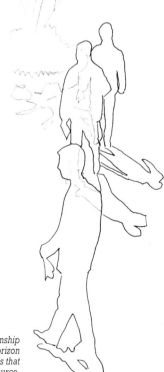

If we analyze them, we can establish a clear relationship among point of view, distance, and location of the horizon line. The conclusion concerning the projected shadow is that its direction depends directly on the light source.

SIMPLE FIGURES

The best geometric figures for laying out drawings are the simplest ones: they are the best approximations of the morphology of the body parts, and they are adaptable to the depiction of movement. The parallelepiped, the sphere, and the truncated cone are the most useful shapes.

Parallelepiped

More than the cube, the geometric shape that is most commonly used in these cases is the parallelepiped: it works fine for framing the torso of a figure in motion. It is also used for long faces, and it can be the best framework for hands and feet. We always have to keep in mind that choosing one framework or another is based on the shape of the body part in question and the movement being described.

Reduction to Simple Figures

The human figure can be broken down into simple geometric figures such as the truncated cone, the sphere, and the hemisphere. The parallelepiped and the cube can likewise serve as a framework. Various parts of the human body move independently from the others, and that complicates depicting them in a work of art.

With a human figure in motion, the artist chooses the simple geometric shapes that are best suited to the representation. Applying the proper perspective to each part of the figure shows how foreshortening works. It provides orientation in doing the best sketch with respect to foreshortening. Depending on the position of the body part that is being drawn, the artist selects a parallel, oblique, or aerial perspective.

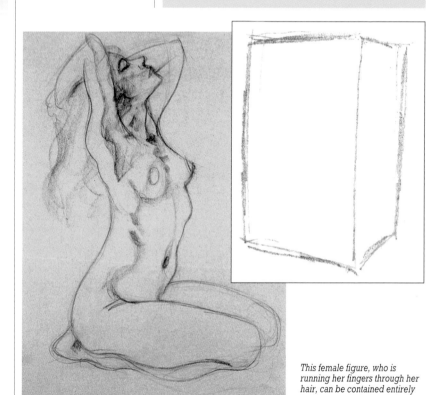

This female figure, who is running her fingers through her hair, can be contained entirely inside a parallelepiped.

Sphere

The sphere and hemisphere are commonly associated with various parts of the human body. The head is not a complete sphere, but from a certain perspective this shape can be used as a framework. Firm female breasts, and the buttocks, can be likened to a hemisphere. The eyes and the movement of the eyelids correspond to an even smaller segment of a sphere.

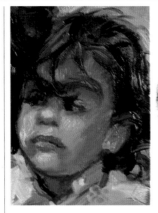

A child's face can be likened to a sphere.

Every part of the body, no matter how small, merits close study; thus, the lips in this position can be seen to resemble a spherical wedge.

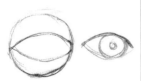

The simple shape that is associated with the eye is the spherical wedge.

Truncated Cone

A truncated cone is surely the most adaptable shape to human morphology in the arms and the legs. In addition, the torso may be represented as a truncated cone, depending on its position.

A truncated cone can represent the forearm. Brush strokes in oils are applied to represent this shape.

MORE ON THIS TOPIC

- Foreshortening **p. 26**
- The Artist and Foreshortening **p. 30**
- Proportions and Foreshortening **p. 32**

Type of Articulation

All these geometric shapes are articulated among themselves; even the spinal column is flexible, and that produces changes of position in the ischia and the hips, and rotation or turning that influences the orientation of the head.

THE ARTIST AND FORESHORTENING

In practice, artists approach sketches on the basis of a simple scheme. They establish all the proportions by comparison with the ideal canons and by measuring in the artist's manner. It's a particularly good idea to identify the important directions in the illustration.

A Simple Sketch

An outline is the immediate graphic representation that reflects the figure in motion and that serves as a model by setting the general limits. The outline can be a triangle or an oval, or can be comprised of two or more simple shapes—say, a rectangle and a triangle. It amounts to the first flat representation of the subject. This outline is very important; as the sketch is developed, it serves as a framework for all the lines. The proportions of this outline have to be as precise as possible in depicting the movement.

Measurements

It is important to practice taking measurements using models in static poses. Taking measurements in the artist's manner is based on determining a measurement that can set up all the important distances between parts of the body when it is multiplied by

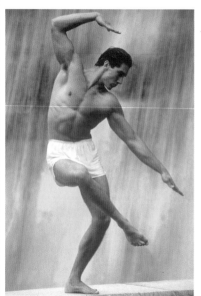

The simple relationship between total height and width is established by measuring in the artist's manner, as long as the figure is in a nearly static pose, as in tai-chi. In this instance, the total height is more or less double the total width.

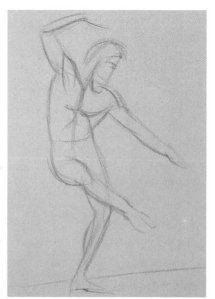

With the figure properly centered on the paper, if the height is double the width, the format is, of course, vertical. The line in the shape of an S-curve and the parallel directions of the left arm and right lower leg are the resolution of this figure.

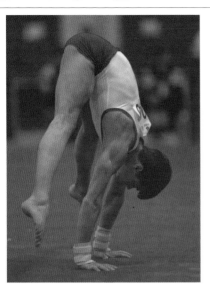

This is the position of a gymnast as he starts to raise his legs.

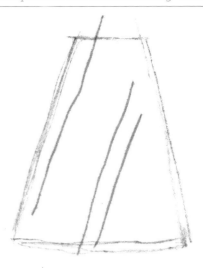

A figure in motion in which the total width corresponds to two-thirds of the total height. Also, it is obvious that it can fit into a regular isosceles trapezoid.

simple fractions. To measure a distance, an artist takes a position in front of the easel and, while maintaining this position, views the model. The distance to be measured is located on the pencil or the paintbrush, from the end to the point indicated by the thumb. All measurements are taken from the vertical or the horizontal.

Figures in Motion

In order to do a coherent outline and adjust the measurements among themselves, maintaining the proportions within their foreshortening, we have to take measurements; but how can we accomplish that with a figure that is in motion? We have to choose the "frozen" position that best represents the movement and work with it.

MORE ON THIS TOPIC

• Foreshortening **p. 26**
• Simple Figures **p. 28**

Position

The positions of all the limbs are located in the outline. This involves locating the parts of the figure that are aligned horizontally or vertically, and identifying parallelisms. Perpendicular directions may also be useful. In fact, in order to frame the outline, artists use any orientation that can be abstracted from among the parts of the figure.

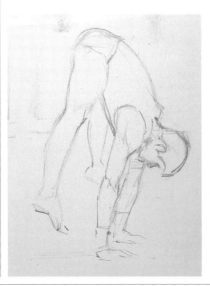

The three parallels to the direction of one of the sides of the trapezoid are the basic elements that facilitate doing the sketch.

PROPORTIONS AND FORESHORTENING

Foreshortening works on the human figure in such a way that the
proportions of the canon serve only for general comparison. As always,
observation is very important, and is the only way to analyze the proportions
of any figure in motion.

The Relative Usefulness of the Canon

When we look at a head in foreshortening, it's difficult to measure the canonical module for a figure, whether man, woman, or child. The reference measurement is derived from the part of the body that is most directly in front of the artist; that is the part by which the proportions of the canon will be adjusted. A body part that is not seen in a direct frontal position will be smaller than the one used for the canon. Let's look at an example. According to the ideal canon, the length from the shoulder to the elbow is the same as the length of the forearm; however, when the arm is bent, the two parts lose this proportional relationship through foreshortening, and the correct one must be established. The proportion indicated by the ideal canon is useful for comparison in all cases. A part of the body that is seen in foreshortening is always smaller than the proportion based on the canon.

Within that general framework, artists must measure the various parts that are seen in foreshortening in order to accurately represent a figure in motion. If that is not pos-sible, they must estimate the size.

An Unconvincing Drawing

If a drawing doesn't present the accurate proportions to communicate foreshortening, it lacks realism. Even after having taken measurements, when all the shapes are outlined in the sketch, it's a good idea to do a few more checks. The easiest one involves moving away from the work and looking to see if the sketch creates a strange impression. You can also turn the work upside down; that clearly shows if the center of gravity has been located incorrectly. All problems can be attributed to irregularities in setting up the proper proportions.

Larger, Closer; Smaller, Farther

When we look closely at a model in a static pose that

Colored pencils are good for doing quick sketches of models such as these, which can be seen at any playground.

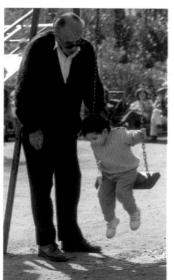

Proportions between the two figures have to be consistent. That is the only way that the movement expressed in each one will form a cohesive whole.

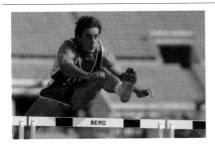

Accentuated foreshortening makes the hands and shoes appear very large.

This accurate disproportion looks exaggerated even when the drawing is first colored in.

MORE ON THIS TOPIC
- Comparative Morphology **p. 18**
- Foreshortening **p. 26**

exhibits significant fore-shortening, we notice that the closest part of the body looks much larger than the rear, which appears to be farther away. What applies to a static pose also applies to figures in motion.

As a result, in all projects and studies in which we draw or paint figures in motion, we have to observe this premise: foreshortening always creates the effect in the spectator of seeing the closest parts of the figure as larger than the ones that are farther away.

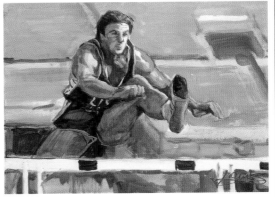

As coloring progresses, the shapes become more clearly defined, and it becomes clear that the proportions are correct. Work by Miquel Ferrón.

However simple any movement may appear, there is a complex coordination among all the parts of the figure.

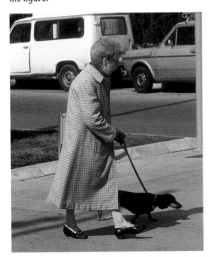

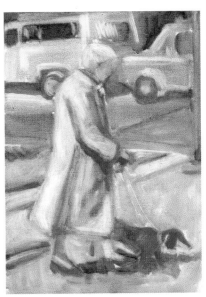

From the very first application of oils, the main thing is to capture the "look" of the subject.

SILHOUETTE AND COLOR

The lines that represent the silhouette of the figure and the outlines of the shapes—in other words, the sketch—serve as a guide for applying shadows and colors. The proportions and the tonal values of the colors have to be accurate.

An Accurate Profile in Foreshortening

The purpose of the diagram, the layout, and taking measurements is to create an accurate sketch. The profile of the figure in motion, with the appropriate proportions in the foreshortening that is exhibited, sets up the limits to be used in applying the shading and color.

Light and Shadow

In addressing light and shadow on a figure in motion, we first have to study the play

Shapes are communicated through a monochrome tonal development.

Weave and Texture

The manner of applying shading and color can accentuate an appearance of weave or texture in the representation. The weave and texture are applied to dramatize the expression of shape.

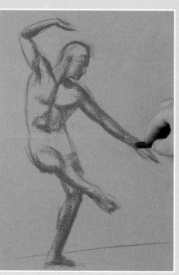

Every medium affords appropriate techniques for creating texture or weave to dramatize shapes, sometimes using coloring instead of lines.

of light on a stationary figure. The light illuminates the body from a point of origin or a focus. There are parts of the figure that appear very brightly illuminated, and others that are less illuminated. According to the type of light, there is a gradual transition to the darkest areas. In any case, there are numerous tonal values that can be established, and several of them can be chosen to represent the most important tonal areas. This system of tonal valuation makes it possible to assign to each area of the representation its corresponding tonal value until the entire representation of a figure in a static pose is completed. With a figure in motion, we often have to imagine how light plays on the different parts of the body; as a result, it can be very useful to have recourse to photographs to use for reference.

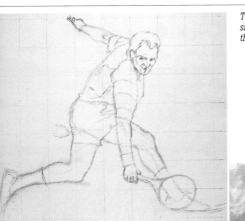

This sketch is the flat representation of the silhouette and the shapes of a tennis player in the act of reaching for the ball.

In applying the initial colors, the figure starts to take on meaning.

Color and Shape

In order to represent shapes using an achromatic medium such as charcoal, or a monochrome one such as sanguine, the tonal values of the respective mediums are the only resource used. Still, the flesh tones of the skin achieve their maximum expression through color. The color value of the figure's skin depends on the nature of the light and the characteristics of the model's skin. Once the proper color for the skin is selected, we have to determine the ambient and reflected colors. This chromatic richness and variety creates an impression of volume in the representation.

MORE ON THIS TOPIC
• The Artist and Foreshortening **p. 30**

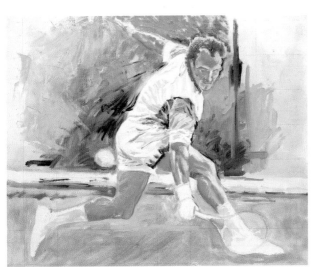

As the color is developed further, the shapes become more clearly defined until the painting achieves a good sense of depth, shape, and volume.

INNER LINES

One element that makes it clear how the shapes of a sketch are related
consists of what's known as inner lines. In order to construct these lines,
we use artistic lines that synthesize the profile of each limb.

The Complete Sketch

The lines of the sketch
define the limits of the outline
that are very important when it
comes time to apply shadows
and color. The most important
line is the one that defines the
silhouette, but it is not the only
one that is needed to situate all
the parts of a figure in motion.
There are some essential pro-

The Artistic Line

The layout and the framing can be
done using lines of approximation.
Still, artistic lines are used to
delineate the profile, the most
important contours, and the inner
lines.

*Magnified detail of the work
mentioned below by Michelangelo.*

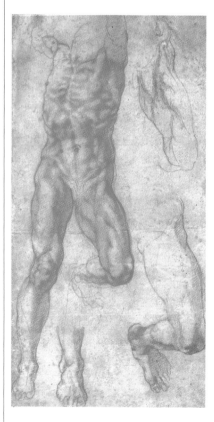

*These studies in sanguine of a crucified man by
Michelangelo are an extraordinary display of how
inner lines are applied.*

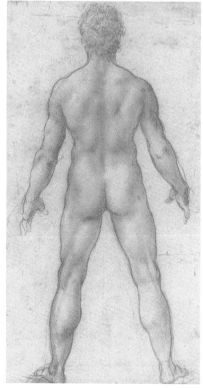

*Leonardo da Vinci. Rear view of a figure. The
smooth gradations that clarify the shapes of the
figure are fostered by the use of artistically drawn
inner lines.*

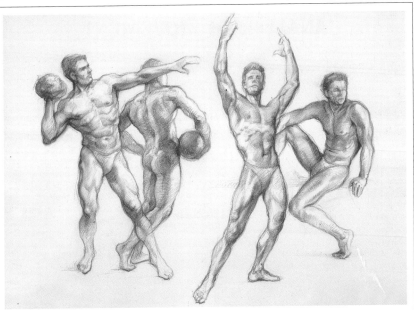

Modern version of muscular figures, which allow for many inner lines. This corresponds to a cultural aesthetic.

files in the body parts that evince foreshortening and that also need to be represented in the sketch, and as a part of these profiles they give rise to the mentioned inner lines.

Interest of Inner Lines

The representation is flat since it is done on paper or canvas. The sketch, without shading and color, is the representation that creates the least convincing impression of volume, but it allows us to see that the proportions are accurate. The only way to convey depth through line is to use inner lines. In doing this complementary facet of the sketch, you set up an immediate visual relationship among the closest and most distant parts, since the inner lines describe a contour corresponding to a nearer part and going inward to another one that is farther away.

Expressing Volume

Thanks to inner lines, all the lines of a simple sketch contain all the elements or references that the artist needs in applying shading and color. That's what makes it possible to do crosshatching in the right direction to create the best texture and a sense of volume.

> **MORE ON THIS TOPIC**
> - The Artist and Foreshortening
> **p. 30**
> - Proportions and Foreshortening
> **p. 32**

Inner lines can also be done with brush strokes, as required by work in oils, acrylics, and gouache, even though these are mediums that don't require the use of linear profiles.

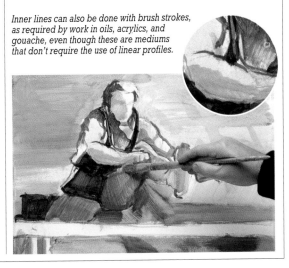

ANALYSIS OF MOVEMENT

In practice, to draw a figure in motion, we have to delve into all the aspects that come into play when the action is carried out. The result of this analysis must be a synthesis of the basic elements that make up the movement.

Observation

A person walking is in continuous movement. The arms may not swing if the subject is holding a bag in one hand and the other hand is in a pocket, but the action of walking implies that the legs are in motion to travel from one location to another. In addition, the head can be turned to look at a partner in conversation or at something else. The task is to determine which parts are called into action and which ones aren't.

Is There a Sequence?

As we observe the movement, a sequence may become evident.

For example, when people walk, they advance one leg and the corresponding foot, and the other one serves as a support until it is left behind in the forward progress; at that time the other leg becomes the support.

This is the sequence that repeats itself again and again as the subject advances.

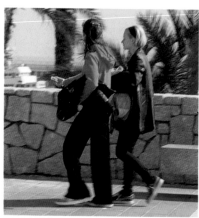 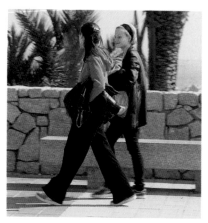

A person walking moves parts of the body. In analyzing the overall movement, we identify a sequence that is repeated every time the person advances the same leg.

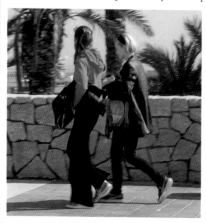 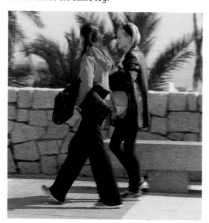

Expression

The difference between a model's static pose and a snapshot in the sequence of a movement is obvious, and it constitutes the expression of this movement. In a fixed pose, the hair, for example, is stationary; it has nothing in common with the elasticity of a person's long hair trailing behind in a race. In a jump, the impulse momentarily counteracts the force of gravity in such a way that the figure will literally appear to fly. Expressing an energetic movement is the opposite of a static position. However, as the movement moderates, there are more possibilities for choosing a more static snapshot of the action.

Selecting a Phase of the Movement

To draw or paint a figure in motion, you have to choose a single phase, normally one that indicates the type of action that is being carried out. This instantaneous, ideal pose raises a number of issues from the moment that a simple sketch is done. It is worthwhile to practice doing sketches from memory after observing the figure in motion; the idea is to capture the "look" of the figure.

With actions that involve great mobility, help from a photograph can be very important, even though many things in a photo may be modified so that it is used only as a complement.

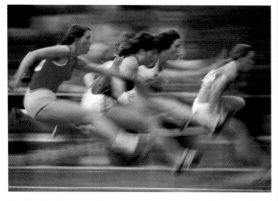

A photo like this one, which captures the movement of the race, is a perfect expression of motion.

MORE ON THIS TOPIC

- Describing Movement **p. 40**
- Continuous Motion **p. 42**
- Help from Photography and Video **p. 44**

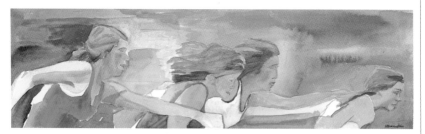

M. Braunstein has done a sketch in watercolors, on the basis of the photographic material, to capture a moment in the race.

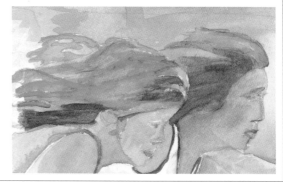

A very kinetic element that expresses the movement in the race is the detail of the long hair that trails in the wind.

DESCRIBING MOVEMENT

With a figure in motion, it is necessary to apply the artist's
knowledge of anatomy. The foreshortening of each body part has
a corresponding position in the skeleton that supports it
and in the muscles that maintain it.

The Anatomy of Movement

When we observe the anatomy of a figure in a static pose, it is easy to establish a relationship between the foreshortening and the skeletal and muscular structure. However, except in exaggerated cases of bodybuilding, static poses don't make muscular features stand out the way they do with a figure in motion, especially when it is strenuous.

What kinds of things can we observe in a person running? The action of the muscles is visible on the unclothed parts of the body, or through tight, thin clothing; we can see protuberances, smoothness, and tensions. With loose clothing, there is the body of the fabric and the way it hangs and stretches because of the movement.

The Muscles Used

A number of muscles come into play that may increase in size and become very noticeable. In men, these may include the calf muscles, the biceps, and the pectorals; in women, except for those with very well developed muscles, the evidence is less visible. In children, especially small ones, the muscles are not readily visible.

Just the same, there are always increases in size. In a person who is walking, the leg that supports the body weight is larger in size, and is under more tension than the leg that is in the air and supporting no weight.

MORE ON THIS TOPIC

- Analysis of Movement **p. 38**
- Continuous Motion **p. 42**
- Help from Photography and Video **p. 44**

The differences in the musculature between men and women are visible. Observation also makes it possible to conceptualize the runner's style. Here is what must be captured to express the runner's allure or modus operandi: the position of the shoes in the stride, the swing of the hips, the movement in the shoulders, and the position of the arms.

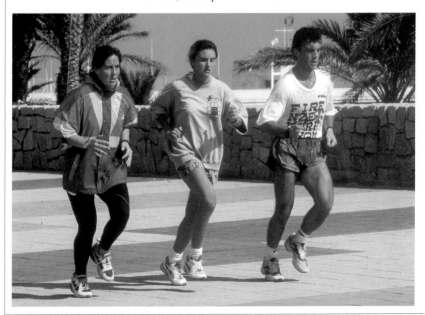

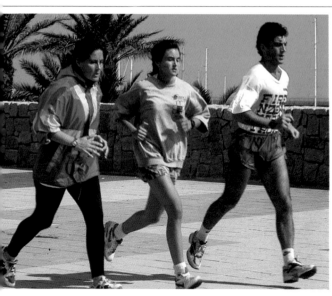

Tight, elasticized clothing slenderizes the figure, but it minimizes the volume of the muscles in action. Loose and light clothing shape the figure and indicate the direction of movement.

The Face Muscles

When a person walks, there are not many changes in facial expression, but in running or jumping, the facial features take on particular shapes. During the upward exertion, they are moved in the same direction, and they fall when the body descends. The most spectacular moment is when contact is made with the ground; the features seem to decompose, stretching downward. This is due to the effect of gravity and the elasticity of the muscles and the skin on the human body. It happens while the individual keeps the face neutral.

When the movement involves a particular facial expression, several muscles are at work all at once. The exertion is almost always accompanied by some grimace or tension. This expression in running is complemented by the effects of gravity referred to earlier, the exertion, and contact with the ground.

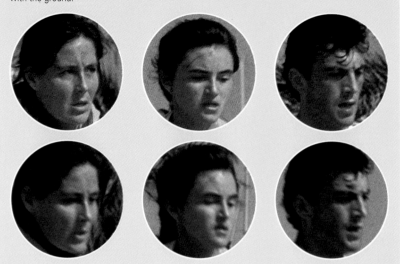

This series of examples makes it possible to contrast different facial expressions.

CONTINUOUS MOTION

With a figure that is carrying out some action, it is possible to differentiate between when the action is in progress and when it has ended. The major difficulty involves drawing the figure while it is in motion. Which snapshot to choose?

A Succession

In creating the movie camera, someone used the idea of dividing a movement into numerous still shots that gave the impression that the figures were moving when the pictures were run one after another at a predetermined speed.

Artists don't have this option. They can only use an image to indicate that a figure is in motion, and this representation has to be sufficiently explicit for the spectator to make the connection between the figure and the movement.

A Representative Image

For some very minor actions, such as a seated person reading a book and turning a page, it is not difficult to start with a fixed pose. Later on a gesture that conveys the movement can be added. Other actions are more complex, and the issue involves choosing a single image that represents the movement, without the benefit of having a model in a fixed pose.

Frozen Movement

The background should include the things that a photograph would capture in the fraction of a second it takes to create an image that is not blurred.

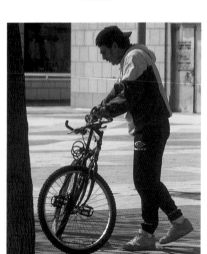

Photographs capture three movements in which a cyclist holding his bicycle by the handlebars approaches a tree. In one frame, he has one foot raised in the middle of a stride. Of the three photographs, this is the one that best communicates movement.

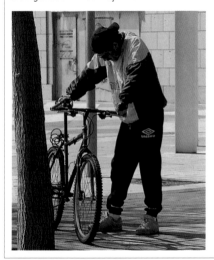

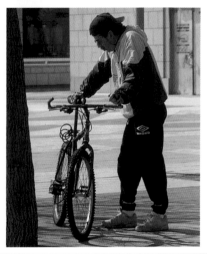

Factors in Expression

In every movement, there is a series of factors that influence its representation and are inextricably linked to one another. This may involve the general inclination of the figure, the particular disposition of all its parts, the expression of the facial features, and so forth. It is difficult for a person to perform a very strenuous physical movement without expressing it through a strained expression, contraction, or even pain in the facial features.

A sketch, no matter how rudimentary, needs to establish the figure's characteristic locomotion.

Gustave Caillebotte. The Floor Brushers. Oil on canvas. This work contains a fine study of the expression of the effort involved in the action of each figure. It could be an interpretation of fixed poses.

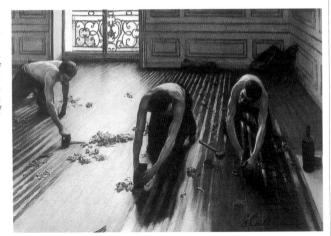

However, the artist's method involves creating a planned outcome of the observed movement. A lot of work involves memorizing the action that is being analyzed and doing quick sketches.

Among the succession of images into which a movement is broken down, the most representative one is chosen to communicate its purpose.

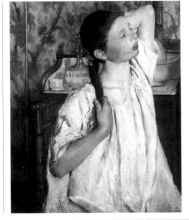

Mary Cassat. Young Girl Combing Her Hair. Oil on canvas. An action such as combing the hair can be represented by first doing a quick sketch of a model in a fixed pose.

MORE ON THIS TOPIC

• Analysis of Movement **p. 38**
• Describing Movement **p. 40**

HELP FROM PHOTOGRAPHY AND VIDEO

Throughout this book, there are many references to the help that photography can provide artists who wish to draw or paint a figure in motion. Nowadays, artists can also make good use of video. Still, technological advances aren't the total answer.

Snapshots

Nowadays, there are lots of things that make an artist's job easier. If photography has certain limitations in capturing a movement, they can be overcome by the use of video.

Presently, it is possible for a person to record a figure in continuous motion in a scene that is fully as long as it is precise. Several videos can be shown and paused at the instant considered to be the most representative of the movement in question.

Sketches and Projects

Artists can work in two directions, both of which are perfectly valid: on concrete material, in other words, with models in action that they can watch; or by creating a work based on accumulated visual memory. It is usual to begin by observing the figure in motion through the help of a still camera and choosing the best frozen image to represent it; that may involve modifying the material in the photograph.

Artists experienced in depicting the human figure in motion have no difficulty in creating a work without the help of a live model or a photograph.

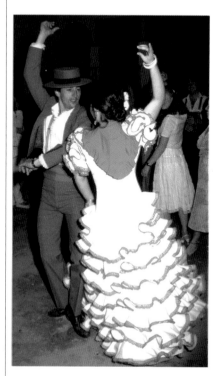

This photograph captures an instant of a couple doing a flamenco dance.

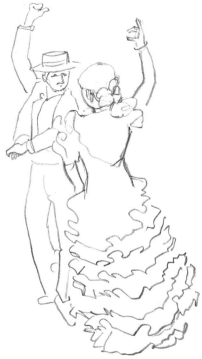

A sketch can be done by referring to the photograph.

The Artist and Movement

Many artists have incorporated the advantages of modern life into their work, but many others prefer to pass them up or make only moderate use of them.

In former times, artists could address this issue only by using their powers of observation and their technique. Today, however, anyone who wishes to progress in the most classical way faces an unequaled challenge. But at the same time it's also an extremely attractive one that often time will lead to a complete mastery of the drawing technique.

MORE ON THIS TOPIC

- Analysis of Movement **p. 38**
- The Articulated Wooden Mannequin **p. 46**

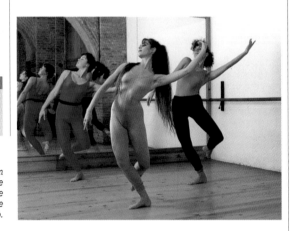

By using a video camera to film a ballet rehearsal, it is possible to isolate the still frame with the figure that best expresses the beauty of the dance step.

A quick sketch can be done freehand from memory.

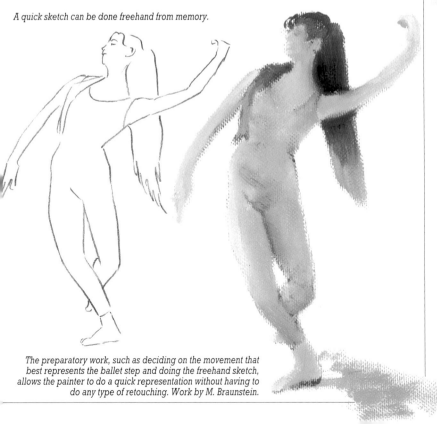

The preparatory work, such as deciding on the movement that best represents the ballet step and doing the freehand sketch, allows the painter to do a quick representation without having to do any type of retouching. Work by M. Braunstein.

THE ARTICULATED WOODEN MANNEQUIN

Another source of help in doing a project on a figure in motion involves constructing a pose with an articulated mannequin. Still, the limitations of the mannequin are very obvious in expressing movement and creating flesh tones.

Foreshortening in Practice

The articulated mannequin is an indispensable tool for working with human figures; it's a way to practice taking measurements and laying out the shapes that foreshortening presents—even the very pronounced ones.

Most artists prefer working with live models, to the extent possible; however, there is always a learning period that comes before sketching from real life, and that involves using an articulated mannequin.

MORE ON THIS TOPIC

- Foreshortening **p. 26**
- Simple Figures **p. 28**
- Proportions and Foreshortening **p. 32**

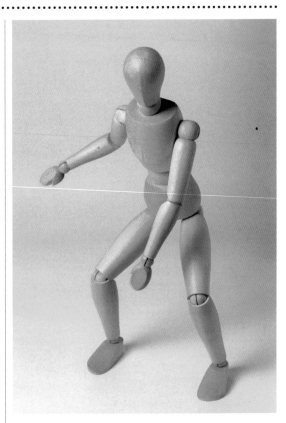

An articulated mannequin can be posed in the defensive movement of a basketball player.

The foot is articulated only when it is represented by a separate unit. The foot of the entire mannequin has no articulation, and as a result it can't duplicate the shape of the foot when it makes contact with the ground after a jump. The simulated foot has no toes that can be moved.

The hand of the complete mannequin has the same limitation as the foot. It has no fingers or capability of expressing movements.

The Postures of Movement

As the name indicates, the articulated mannequin is an assembly of parts generally made of wood that approximate the most representative shapes of the human body. There are both male and female versions, and even though they are harder to find, there are also mannequins

that represent children and babies. You may also encoun-

The head has no facial features, and it can only be positioned approximately with reference to a small ridge in the wood.

ter separate mannequins for specific parts of the body such as the hand and the foot.

In order to arrange an articulated mannequin so that it expresses an instantaneous segment of a movement, you need to become adept at identifying relationships in a figure in motion. However, an articulated mannequin only partly reproduces a human body in movement, since it has some serious limitations. In any case, in some projects it can help resolve issues of proportions due to foreshortening.

The Mannequin's Limitations

There are some simple and economical mannequins that aren't very useful. Artists really need to experiment with postures using a mannequin that faithfully reproduces the articulations of the human body; elbows, for example, don't bend backward.

However, even with a good articulated mannequin, it is clear that it doesn't have the same range of movements that the human body does. A mannequin can't reproduce yoga poses; the trunk can't bend forward very far; one leg can't be bent entirely double at the knee, and so forth.

The articulated mannequin is a poor representation of the body if you compare it to a live model.

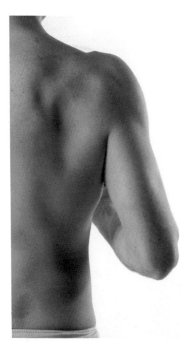

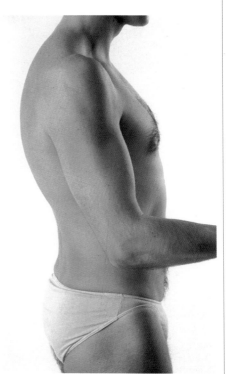

The articulated mannequin provides only a guideline for the effects of light and shadow. A human model, on the other hand, offers a broad palette of flesh colors. In using an articulated mannequin, the artist has to invent that palette in an effort to humanize the image.

THE PHYSICAL EXPRESSION OF EXERTION

For a deeper appreciation of a figure that is carrying out an action, it is necessary to have a profound understanding of how to convey the movement by thoroughly analyzing it and looking for information that makes it possible to create synthetic, yet very descriptive sketches, especially when the model is exerting some effort.

A Different Problem Every Time

The problem is different with each project. Even though athletes may practice using the same style, the individual features of each body require that every case be studied separately. Even in projects where a live model is not observed directly, the individual's facial features have to be represented, and the expression has to convey the exertion.

What Muscles Are Like

The characteristics of the muscular structure are different from one individual to the next, and are dependent on age and sex. The artist captures the general appearance of an individual and then imparts that "look" to the representation.

Depending on a person's physique, the skeleton is visible in several parts of the body. In the hand of a man who is jogging or throwing a punch, the features of the skeleton and its coverings become apparent: muscles, tendons, and skin.

A simple sketch that depicts the action can be used as a point of departure for modeling the characteristics of every muscle in action.

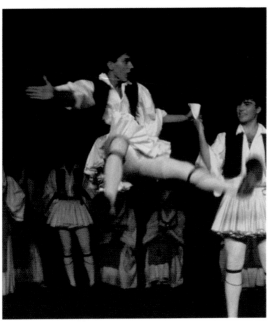

The jumping Greek dancer captured in mid-air by the photograph is supported only by another dancer holding a handkerchief. This type of observation is important in understanding the movement.

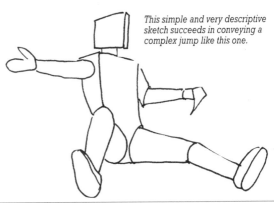

This simple and very descriptive sketch succeeds in conveying a complex jump like this one.

MORE ON THIS TOPIC

- Muscles in Action **p. 50**
- Facial Expression **p. 52**
- Gravity **p. 54**

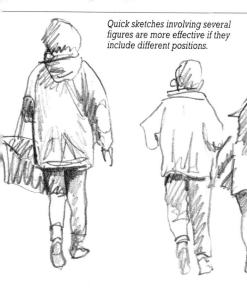

Quick sketches involving several figures are more effective if they include different positions.

The Clothing

Even though the figure may be dressed, the clothing is only a covering that never completely hides the nature of the body beneath it. A well-shaped leg, strong and robust, should be visible as such through the pants. A loose shirt that surrounds a dancing body describes a movement around it that can't conceal its shape or size. If the body doesn't match the depiction of the movement conveyed by the clothing, the inconsistency is obvious; at the very least the features of the model in motion are represented inaccurately.

Exertion: From Mild to Intense

It is worthwhile to compare two examples: one involving a hand moving through the air without muscle contraction, allowing it to float with inertia, and another involving a clenched fist that is moving forward. This same hand is obviously a man's, with its characteristic slender fingers that are neither short nor long.

The most noticeable difference is in the knuckles and the different tension and shape of the fingers.

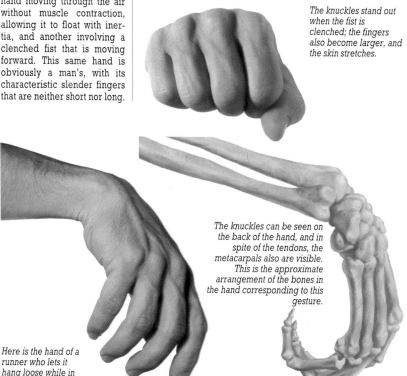

The knuckles stand out when the fist is clenched; the fingers also become larger, and the skin stretches.

The knuckles can be seen on the back of the hand, and in spite of the tendons, the metacarpals also are visible. This is the approximate arrangement of the bones in the hand corresponding to this gesture.

Here is the hand of a runner who lets it hang loose while in motion.

MUSCLES IN ACTION

When a muscle contracts, along with the tendons at its two extremities, it increases
in volume and becomes shorter. Muscle fibers are smooth and are grouped
in bundles that make up the shape of the muscle. Much of this is visible
to a careful observer.

Tendons

All the muscles that are
of interest to artists are
attached to the skeleton
by means of tendons.
Some of these white
fibers are easily detected
under the skin when they
are under tension. When
some tendons are used,
they become very visible.
Examples include the
sternocleidomastoid, the
palmar tendons, and the
supinator, the largest one
that covers the tibia.

The expression of ten-
sion in the tendons goes
hand in hand with the
bulging of the muscle
bundles under contrac-
tion. Depending on the
foreshortening of the
figure in motion, the pro-
file of the tendons also
takes precedence over
the inner lines of the
drawing. Artists can ex-
periment with the pa-
lette to represent this
tension accurately.

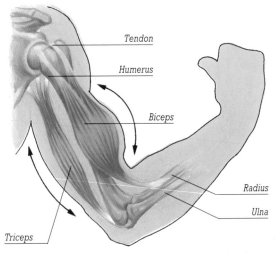

As an example, let's consider the action of the biceps and the triceps.
Here, both muscles are working to lift the forearm. Because of the
contraction, the biceps have greater volume.

Muscles Increase
in Volume

It is fitting to observe care-
fully how a muscle is trans-
formed when it is called into

Now, when the forearm is
extended, the triceps
contract while the biceps
decrease in volume and
contraction.

play with increasing intensity.
The biceps and triceps show a
marked increase in volume
under contraction. In greater
contraction, the volume is
concentrated in the central
part, producing a general
shortening of the muscle and
bringing the tendons into
more direct action.

The triceps contract in
movements where the arm is
moved to the rear. The biceps

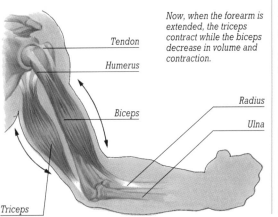

MORE ON THIS TOPIC

• The Physical Expression of
 Exertion **p. 48**
• Facial Expression **p. 52**
• Gravity **p. 54**
• Sports **p. 76**

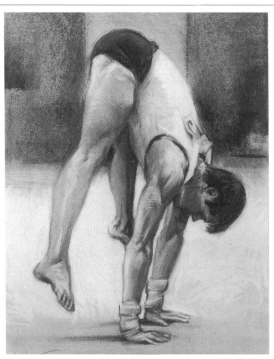

Gradations done in sanguine allow representing the muscles, and white lines represent reflections off tendons in action. Drawing by V. Ballestar.

are under contraction during a movement. The bulge does not occur in a random location, but where the bundle of muscle fibers experiences the contraction. These profiles are softer in children, in the female figure, and in male figures that are not well muscled. Still, this softness doesn't mean that there is no increase in the volume of the muscle; it is simply the most accurate representation of the musculature of the figure in question.

We should try to avoid drawing profiles that are overly linear or bulging.

contract in moving the arm to the front, and also in any other action involving lots of tension or from lifting a weight.

Profile

The inner lines and the contour lines of an illustration acquire greater meaning if they accurately depict the profile of the muscles that

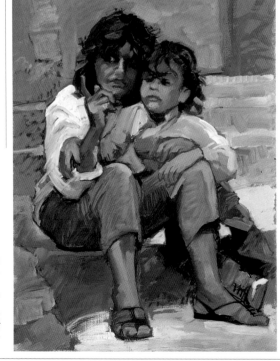

Look at the hands. The hand gesture of the woman involves a profound study of proportions, foreshortening, and the articulations: knuckles, muscles, and tendons. This is a task that takes on importance because of the other three hands that are held in a relaxed position.

FACIAL EXPRESSION

The facial expression of a figure in motion calls into play several muscles
of the head and the face. They communicate the feelings that produce them
and go along with the type of movement being carried out.

The Transformation of the Facial Features

A face doesn't have to express or communicate anything, but any expression, no matter how subtle or ambiguous it may appear, brings several muscles into play. Human expressions, such as laughing, are very difficult to depict, and this difficulty increases in the presence of foreshortening.

The artist approaches a sketch of the head using the same principles as in drawing the whole figure. A simple sketch is needed in which the locating lines are situated with reference to the fore-

Photography is not always a faithful reflection of facial expression, and even less so with a small child. In this case, the photograph is an aid in constructing the expression.

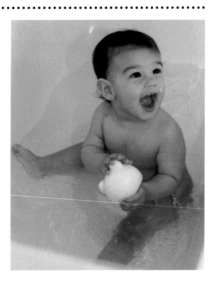

shortening, and the outlines are drawn within the established reference lines in order to depict all the features of the face.

Concentration

When the eyelids are half closed, that is a sign of concentration, just as when the eyebrows nearly meet in the middle and a determined grimace on the lips tightens the mouth and transforms it into a thin line. An expression of surprise is very different, and it is often accompanied by

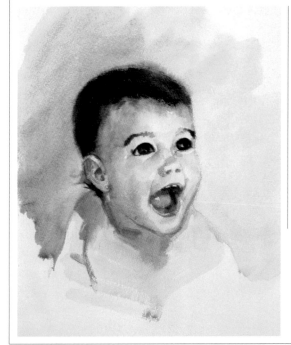

The liveliness of this child's expression is due especially to the freshness of the watercolors and the artist's interpretation in an effort to capture faithfully the youngster's essence.

Exertion and Pain

There is a measure of determination in exertion, and then there is also fatigue. The mouth, at first partly open, has just opened completely to admit more needed air. Then there may be an expression indicating a loss of control and weakness. When the exertion crosses the threshold into pain, the face takes on an extraordinary appearance. All the muscles of the face become contracted. Still, when we do a representation of an entire figure, the facial expression must serve as a summary of the whole; it is crucial to capture the expression accurately.

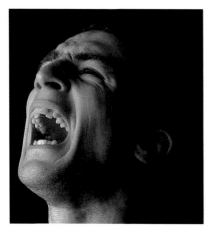

A model in a fixed pose of short duration; since this attitude is difficult to maintain, it encourages practice in doing quick sketches.

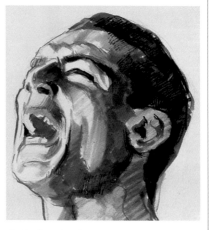

It takes just a few lines and the application of some color to capture the essential expression.

raised and arching eyebrows, eyes wide open, the mouth partly opened, and the jaw slack.

Movements by athletes are usually accompanied by expressions of concentration. Only in certain disciplines, such as dance, floor exercise, and figure skating, is a more sedate facial expression required, which is contradicted by the effort being exerted.

The facial expression is a major factor with figures in motion in the realms of tennis, track, soccer, and other sports.

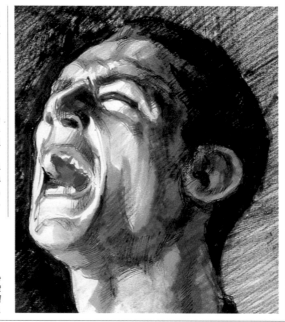

Afterward, more color can be applied to finish rounding out the shapes. Work by Miquel Ferrón.

GRAVITY

Even in full motion, a figure must appear to be in harmony with the forces
to which it is subjected. The softest parts of the body are particularly significant
in this regard.

Contact

Contact with some support surface is usually established through one or both feet, but an athlete doing a cartwheel may contact the floor with one hand, a hand and a foot, two hands, two feet, or one foot. The manner of contact is explained by the support as well as the impulse, and the entire locomotive apparatus of the figure in motion has to demonstrate consistency with this contact. In drawing, the majority of the work is the result of exhaustive observation and practice.

Impulse

A figure that is running a race needs an impulse to propel the body forward. The leg that is pushing off must show a certain type of contact with the surface, and it is

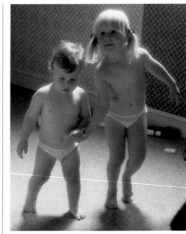

Observing the tiny bare feet of these children helps us understand how important it is to explain the way contact is made with the carpet in order to convey the movement of walking.

MORE ON THIS TOPIC

• Describing Movement **p. 40**

In order to picture the contact properly, we first have to be sure that the outlines are correct.

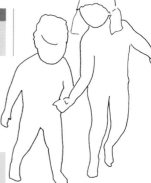

The Center of Gravity

With a figure in an immobile position, whether standing, seated, reclining, or stretched out—or for that matter, in motion—the center of gravity is easy to locate. It can be located at the height of the navel, halfway between the front and the rear of the body.

It is also important to understand how the polygon of support works. A figure in motion, walking or running, with some point of contact with the ground, has an unstable balance without an adequate impulse. A vertical line that passes through the center of gravity cuts into the polygon of support, which sometimes is reduced to a mere line.

There are many possible positions in the air, such as the ones used by platform divers or surfers; it is important to study these, too, to avoid inaccuracies.

subjected to a force that brings tendons and muscles into relief.

All of this is done to produce the necessary impulse and counteract the effect of gravity so that the body can rise and jump. Meanwhile, the other leg reaches forward with the proper tension to keep it in the air and complete the stride.

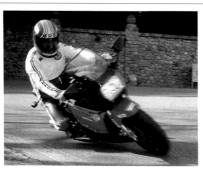

In this case, the figure is in contact with the motorcycle.

The Landing

Another aspect of the race, in addition to the forward impulse, is the resistance encountered at the instant the body confronts the force of gravity when the foot makes contact with the ground.

The purpose of the sketch is to include the right lines for explaining the contact between the body and the vehicle. Several attempts may be needed.

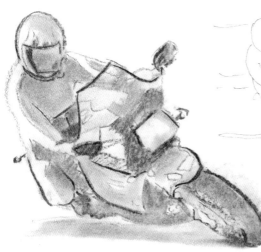

Calling on accumulated experience with this subject, M. Braunstein did this quick charcoal sketch.

In the Air

At other times in the race or the jump, the figure in motion appears suspended in the air. There is no contact with any surface. The effect of the impulse is, of course, well defined, so this type of snapshot is rich in suggestion and makes possible great expression of movement.

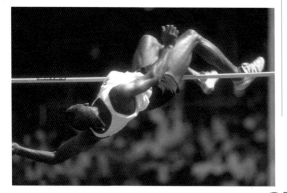

Here is the moment immortalized by the camera: in this instance the figure has no contact with any surface. It is a very useful exercise to commit the profile to memory.

QUICK SKETCHES

With figures in motion, sketches are often done quickly and on the spot.
Quick sketches of poses are the best introduction to this type of drawing;
these usually take about ten minutes, and sometimes less.

Models

There is sometimes a way to suggest some movement in the pose of a figure that is serving as a model. Still, these poses can't be held for a long time, and the sketch will have to be done quickly. As a result, practicing quick sketches from live models in poses that are held for just a couple of minutes is an essential exercise for mastering foreshortening; this is a prerequisite for dealing with figures in motion.

The simplest type of quick sketch is one that includes only the outlines. The most complete sketch also includes a study in colors, also quickly done, that includes two or three hues.

Parks are often a good place to practice quick sketches of figures in motion.

There are people walking, old people, perhaps some runners, plus children of all ages. The first task involves observing some figure that attracts our attention. Then, using all the

The process of synthesizing the profiles and the inner lines is applied art on the part of the illustrator; it also contributes to style and interpretation. Work by Raset.

Shapes are also important in quick sketches, as this watercolor by V. Ballestar demonstrates.

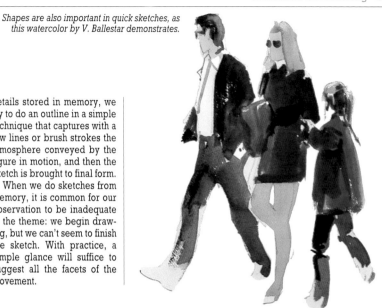

details stored in memory, we try to do an outline in a simple technique that captures with a few lines or brush strokes the atmosphere conveyed by the figure in motion, and then the sketch is brought to final form.

When we do sketches from memory, it is common for our observation to be inadequate to the theme: we begin drawing, but we can't seem to finish the sketch. With practice, a simple glance will suffice to suggest all the facets of the movement.

Technique

You can use any medium or technique for doing sketches. The rapidity of execution makes it necessary to use an immediate medium and a simple technique, using highly descriptive line or color. As we have already remarked, drawing a figure in motion is probably the most complex challenge that an artist faces. Based on a quick sketch, the artist extracts enough information to create the figure in motion using mediums and techniques that involve greater elaboration and a greater investment of time.

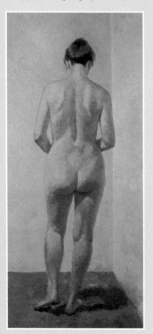

This rear view of a nude, done in oil by Badia Camps, shows the artist's great mastery and knowledge of female anatomy. This proficiency would not be possible without years of effort devoted to practice with sketches and projects.

Synthesis

In all sketching, there is a synthetic process involving shapes and outlines. In the case of a figure in motion, this synthesis is provided by the type of movement and the muscles that make it possible; this synthesis is even more important with the inner lines. So in doing sketches, the artist decides on the most important lines for any specific movement. The rapidity of execution requires them to be the essential ones that depict the entire movement, leaving no room for uncertainty.

Watercolors are a good choice for doing quick sketches, for the brush stroke simultaneously provides color and delineates the shapes.

MORE ON THIS TOPIC

• Inner Lines **p. 36**
• Analysis of Movement **p. 38**
• Describing Movement **p. 40**

MEDIUMS FOR DRAWING

The graphite pencil, charcoal, and sanguine are the traditional mediums
for doing quick sketches of figures in motion. Line and shading or coloring,
with or without crosshatching, form the basis of the techniques. But any type
of drawing will serve for sketching.

Line

Every profile has to be rendered artistically in outlining or drawing a figure in motion. The control that can be exerted on the line makes mediums such as the graphite pencil, charcoal, sanguine, ink applied with a brush, and colored pencils the ideal mediums for doing these outlines and drawings that portray movement. In a line that is done artistically, the width and direction are adapted to the requirements of the different muscular shapes.

MORE ON THIS TOPIC
• Quick Sketches **p. 56**

Shading and Coloring

If the line is the key to the profiles, shading and coloring are done to create different tonal values that, once applied to the representation and using the outline as a guide, succeed in conferring shape to the subjects.

Shading and coloring are done with respect for the tonal value as a system of communicating light and shadow on the figure. These techniques are based in shading or applying colors, whether using visible crosshatching or keeping the lines imperceptible.

Crosshatching: There are many types of crosshatching, and the artist must choose the most appropriate one. Crosshatching involves superimposing successive series of lines until the area to be shaded or colored is filled in.

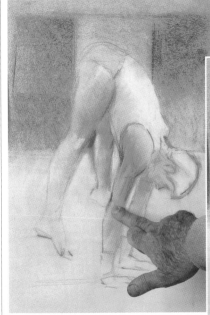

The outlines of the figure can be drawn with the stick of sanguine.

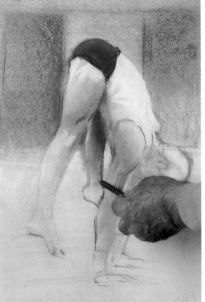

In working with sanguine, a common practice involves creating gradations by rubbing and blending the colors with the fingers.

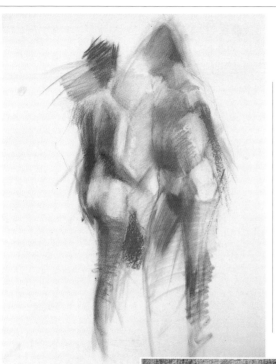

The artist's interpretation and style become clear with the first applications of color.

Direction

The direction of each series of lines in cross-hatching is determined through careful study. With a single set of lines, the direction must correspond to the one indicated by the perspective; in other words, each line follows the part of the figure that lies on a plane passing through the horizon line; the line is related to a theoretical plane.

Without crosshatching: Another way to shade or color involves using lines so densely packed together that their contours and breaks are no longer visible.

Consistency of Tone

In order to create a good impression of volume in the figure in motion, it is useful to do shading or coloring with or without crosshatching to preserve tonal consistency and to create an effective chiaroscuro.

Colored pencils can be used to create quick sketches, and on more elaborate complete works. These pencils need to be applied on top of one another to create mixes and contrasts. These are very painstaking works that require a worktable and time for applying all the layers of color.

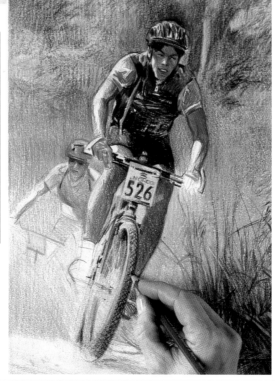

PASTELS

With their immediacy and their potential for chiaroscuro, pastels are an ideal medium for drawing or painting figures in motion. The artistic line can be subdued or bold, and the chiaroscuro is based on blending the gradations.

Pastel Lines

The lines that can be created with pastels make it possible for us to speak of them as a drawing medium. Pastels allow us to draw artistically and create the profiles of a figure in motion and convey precise inner lines.

Pastels are an ideal medium for reproducing flesh tones through blending and shading.

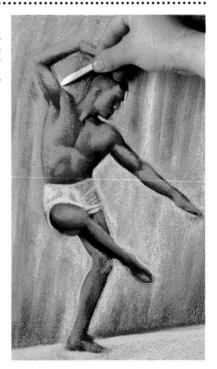

Chiaroscuro

Blending techniques guarantee the wonderful qualities of chiaroscuro that are proverbial with pastels. Nearly photographic realism, soft flesh tones, and the descriptive capacity for all kinds of fabrics, which can be achieved immediately, make pastels the ideal medium for painting figures in motion.

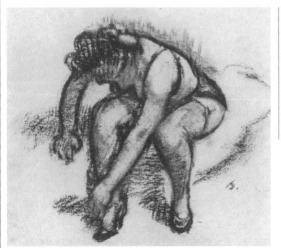

Colors

Pastels are an ideal medium for applying colors without leaving visible strokes. The side of a stick or a small piece of pastel can be used to cover any area smoothly. It is used with light pressure and several passes are used to build up the desired color.

Many pastel works are often preceded by sketches like this one by F. Serra, which are colored with sanguine.

Edgar Degas created a very extensive body of work that includes female figures in motion. Woman in the Bath *is an example of moderate movement of a nude figure.*

Blending and Fading

Colors can be touched up once they are applied to paper by using techniques of blending and fading. These techniques are also common in drawing with charcoal and sanguine, which, like pastels, are dry mediums.

To use fading, you merely have to go over the color with a cotton cloth, your finger, or a cotton swab to lighten it and spread it out, even-tually eliminating any visible lines.

To fade a color, repeatedly pass the finger (the most commonly used instrument) over the layer of color and press down on it. The idea is not to remove the color, but to homogenize the layer.

Colors or Values

The impressionists and the fauvists created a current of interpretation that affects how the figure is treated, and that consists of using pure colors almost without any subsequent modification to set up direct contrasts among complementary colors.

Reliance on color values, on the other hand, is the classical interpretation that reproduces all the values of color and tone. It is a method of applying the colors of chiaroscuro with blending and fading, and, in comparison with the application of pure colors, it creates more realistic results.

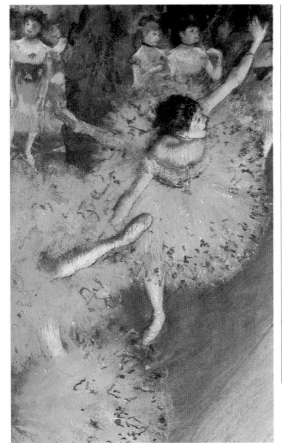

Edgar Degas. Ballerinas. *Clothed female figures executing dance movements.*

OILS

Working in oils can be approached on the basis of adequate sketches and outlines of figures in motion. This medium requires applying the color in two or more sessions, and it dries slowly. Still, because of the richness of its textures, it remains the medium of masterpieces.

Oils are applied in sessions; the process begins with an initial coloring using diluted paints. This is a thin layer intended to provide an overall color scheme.

Brush Strokes

The marks left by the brush contribute to expressiveness and dramatize certain outlines; brush marks are also the foundation for creating textures.

Oils are a medium that requires a first coat with diluted paint to avoid crazing later on. The liquidity of the paint used in the first coat usually means it is not as strong as the colors normally used. Just the same, in a second session, using paint that is only slightly thinned,

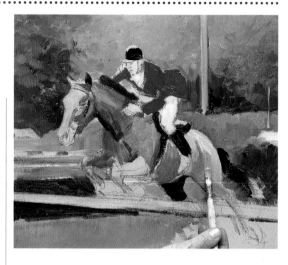

the direction and the breadth of the strokes with the brush or palette knife serve to juxtapose colors on the appropriate surface. In the process, the intent to create texture and rhythm starts to become evident.

In subsequent sessions, when the first coat has set (that is, it has dried enough so that it doesn't leave a mark on the finger when touched), successive coats are applied to create the texture and volume that the figures need.

Reflections and Shapes

Given the versatility of oils, it is possible to represent volume very effectively with an extraordinary chiaroscuro. With painstaking work with the palette, oils allow the artist to work with values of color and tone. One very important aspect of volume consists of creating reflections, and oils require the use of lots of white in the color of the figures and their clothing. Since this is a color that grays easily, the brush strokes that create reflected light are applied in the last session; they constitute the final details.

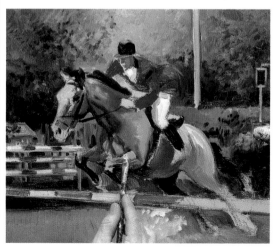

Quentin Massys. The Moneychanger and His Wife. *The painter depicts the natural gestures of a person counting coins and of another turning the page of a book.*

MORE ON THIS TOPIC

• Quick Sketches **p. 56**

Transparent Oils and Glazes

As oils are diluted, they become more transparent. Prepared in that way, they can be applied on an area already covered with dried paint to create a color by overlaying with this transparent glaze.

Dense, Opaque Oils

The versatility of oils allows them to be applied in different ways. When they are thick or dense, they are very opaque. This makes it quite easy to do corrections by covering one layer of dried oils with another dense one.

With oils that are still wet, the mistake is corrected by producing a mix between both wet colors.

Gradations

With thick oils, you can create shades of a color by adding white to the paint and lightening it with other light colors, according to the color theory for artists.

With transparent oils, it is common to use the white of the canvas to create shades, and to dilute the paint to different degrees. Also, darker color tones are created by imposing glazes of the same color over one another. This is the classical method; it is very slow, for you have to wait for each glaze to dry before adding the next one; however, it has tremendous possibilities.

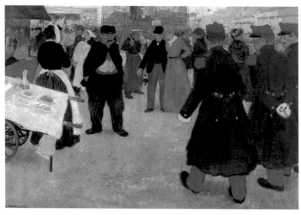

Henri Evenepoel. Celebration at les Invalides. *All the figures appear to be walking.*

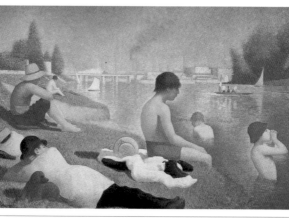

Georges-Pierre Seurat. Bathers at Asnières. *The painter uses his interpretation and the pointillist technique to depict movement.*

WATERCOLORS

Despite the difficulties involved in working with watercolors, this is undoubtedly the medium that brings the greatest freshness to quick paintings of figures in motion. Its different techniques require careful use and control of water to produce good results.

Color and Texture

The transparency of diluted watercolors is proverbial, and this lends a unique chromatic appearance to paintings of figures in motion.

Texture is created by super-imposing layers, alternating the various techniques of wet over wet, wet over partially dry, and wet over dry. To create a luminous watercolor, the order of the layers is

Spontaneity

The freshness of a painting done in watercolors depends on several factors. With regard to a figure in motion, or for that matter, any other model, washes and brush strokes have to be very confident, without retouching areas of color. As a result, you need to start with a good outline, and you have to analyze the sequence of work and decide on the techniques you intend to use before beginning to apply any paint. Then the color of each stroke or wash is chosen with the utmost care, and applied in the proper manner.

Nothing is more displeasing than a watercolor that has been touched up too much. With practice you will gain sensitivity in recognizing the optimal moment for declaring the watercolor to be finished and ceasing to work on it.

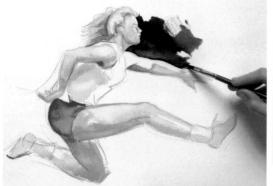

guided by the premise of dark over light.

Using the Brush

Brushes of different sizes deliver different amounts of pigment and water. The size of the brush is chosen in accordance with stated purposes and the type of wash or brush stroke desired. For large washes, even a palette

In this case the entire figure has been painted first. When the paint is completely dry, the coloring of the background begins. Using this technique, where wet is put on next to dry, we avoid mixing the green with the dry washes.

With this technique, the hand movements used to create the outlines have to be very precise, otherwise the space reserved for the representation of the figure will be invaded and become distorted. The washes for the background will provide greater depth to the entire work if they are not perfectly homogenous.

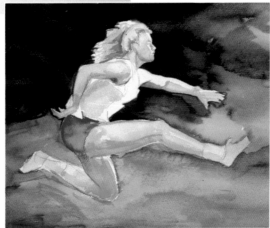

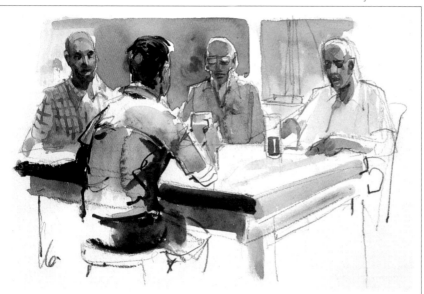

The basis of a successful watercolor is a good guide in the form of an outline, plus an analysis of the order in which the washes are to be applied.

knife can be used, but for details and the signature a very fine brush is used.

It is critical to use great skill in controlling the brush strokes and the outlines as the colors are filled in; that will avoid the necessity of doing corrections.

Controlling the Water

In order to apply the different watercolor techniques, to create shades of a single color, to mix colors by overlaying, and so forth, the artist controls the proportion of water and pigment, plus the degree of wetness in each area of the work.

This control of the water goes along with the order established for the different washes and overlays.

The freshness and luminosity of a watercolor are the result of lots of practice, as in this work by V. Ballestar; that skill is cultivated by doing many quick sketches.

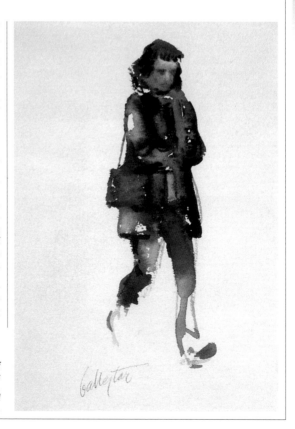

ACRYLICS

Acrylics are among the most modern of the pictorial techniques. Their rapidity of execution and short drying time make them ideal for many advertising projects, specifically for posters. Used properly, they can even rival oils.

Rapidity

Even though the quick drying time of acrylics is an advantage, it can also become a problem. That's why drying retardants are used; these products are easy to find in any store serving the fine arts. Adding a little retardant to the paint prolongs the drying time and makes it possible to create the desired texture.

Different Textures

Acrylics can be used to create the appearance of watercolor, gouache, or oil. For that purpose, the right additive has to be mixed in with the paint. Acrylic medium is used to dilute the paint, and acrylic gel is used as a thickener, but they make the colors more transparent. The medium and the gel can be either matte or glossy.

A little water can also be used to lighten a color and

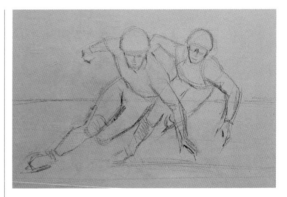

In this case, the outline for a painting in acrylics is done on canvas.

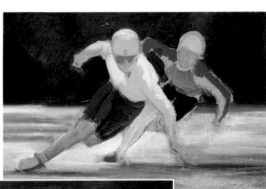

The whole canvas is first colored in to create an overall color scheme.

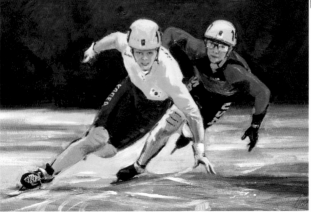

With acrylics, the paint dries so quickly that a second coat can be applied in the same session to create the appropriate texture for the figures in motion. Work by V. Ballestar.

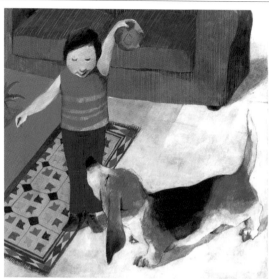

This child's illustration by Judit Morales shows the various textures that can be created by alternating transparent, semi-transparent, and opaque layers.

Drying Retardant

This product may be a necessity for adjusting the drying time and creating the desired textures, but you need lots of practice in determining the right quantity to add to the paint. This increases the complexity of deciding on the colors to be used in a mix and the additive required to achieve the desired effect.

create a very transparent layer.

Watercolor effects with acrylics can be created using medium or just water. With medium, gel, and thickeners (such as pumice powder or pulverized marble), it is possible to imitate oils. The effect of gouache is immediate with the addition of a little medium, but without diluting the acrylic too much.

Acrylics can be used in alternating all these effects in a single work; in addition, this type of paint can be applied to any surface that is free of oil and grease. No wonder it has been adopted as the usual medium for many artists, who have found it to be an inexhaustible source of possibilities for creating textures while working quickly, and which allows for any number of corrections.

MORE ON THIS TOPIC

• Quick Sketches **p. 56**

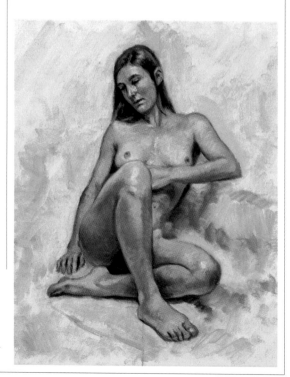

You have to paint lots of figures in static poses before tackling figures in motion. Jordi Segú has achieved a great degree of realism in painting this nude.

VALUATION

By analyzing the different tonal values, we can establish a gradation system that allocates each tone to an area of the representation. The set of values expresses the volume of the figure in motion as long as the location is respected.

Movement and Light

A figure that is performing a specific movement and is illuminated by a certain light shows differences of color and tone over its entire surface, including both skin and clothing, and that also applies to the surroundings. When the skin appears light, this involves a light tone; when it appears dark, we need a darker tone. Based on the observation of the model, it becomes clear that there are a limitless number of tones for every color.

The articulated mannequin can be used to locate some tonal values that will create the shapes when they are applied to the illustration.

Numerous Values

When we wish to depict a figure in motion, depending on the medium chosen, we look for achromatic tone values for mediums that are used in black and white; monochrome values for different tones of the same color; and tonal values for the entire mix of colors when we work with a complete palette.

The entire tonal spectrum is used to create representations on paper, cardboard, canvas, and wood.

The different muscular tensions are conveyed by different intensities in the shading. Comparing the seated male figure with the other ones in motion, it can be seen that the greater the muscular contraction, the greater the relief, with the resulting increased contrast between light and shadow.

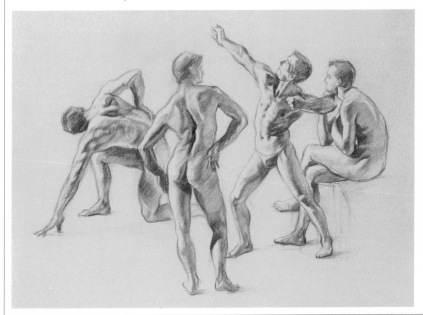

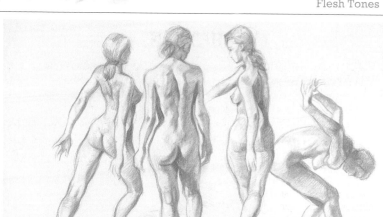

With female figures, which are generally less muscular than men, the distribution of tones has to be reproduced faithfully in accordance with the skeletal structure. The outlines are curvilinear, and the shapes are turgid.

Light and Shadow

Conveying shapes is a function of shading and coloring. The parts that appear more illuminated are done in lighter tones. When the artist progresses to shadows, increasingly darker tones are used, with the darkest ones obviously used for the deepest shading.

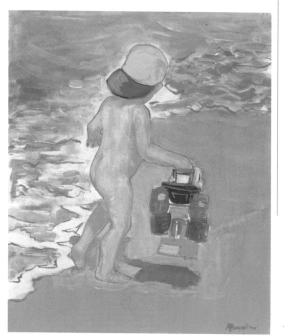

The Valuation System

In order to apply the valuation system, it is sufficient to establish just a few values: the lightest and darkest tones serve as references in choosing three or four intermediate tones.

Based on these few tonal values, and on the appropriate techniques for each medium, we can establish gradations between two consecutive tonal values and avoid abrupt changes in tone. This is how the delicate chiaroscuros are produced that explain the gradual progression from light to shadow.

M. Braunstein uses a mixed technique in this illustration of a child at the beach. To represent the colors of a nude figure, the palette is used to create the flesh tones in light and shadow.

FLESH TONES

Work with the palette has to be exhaustive in order to create the colors used to depict all the chromatic qualities of the skin. This involves working with the color characteristic of every skin, and under the various effects of light.

Many Skin Colors

Every individual has a unique skin color, but in addition to that, light can affect the colors that we perceive. The first task is to analyze the color of the skin on the basis of the effect that the illumination produces on the figure, and then we can study the available palette of colors. The mix that will allow representing the skin is then planned in accordance with these colors.

As a general rule, the flesh color appears warmer in the light than in the shadow.

MORE ON THIS TOPIC

• Valuation **p. 68**

All Colors

The flesh color is associated with a basic mix composed of a little carmine or vermilion, a dash of yellow, and lots of white for white skin. A dark tint entails adding burnt sienna or English red. Copper-colored skin requires the addition of a little ochre. To reproduce the very dark or black skin color, burnt umber and a large amount of blue are needed. If you add the characteristics of the light that illuminates every type of skin, you will end up with an infinite number of color mixes that can be used for flesh tones.

Warm Flesh Tones

The mix for reproducing flesh tones involves various manufactured colors in specific proportions. This mixture is said to be a warm one when warm colors are used such as yellows, oranges, reds, carmines, and ochres.

A light shade of this mixture can contain lots of white, except with watercolors. Just the same, we should note that white can make the color lighter, gray, or colder if it's not added in the proper quantity.

As the shadows progress, earthy and umber colors that

We have to study the individual skin color of every figure.

Colored pencils allow detailed depictions of the differences that exist between illuminated and shaded flesh tones.

Pastels are an ideal medium for depicting all the flesh tones, with their chiaroscuro and gradations. Work by Yvan Viñals.

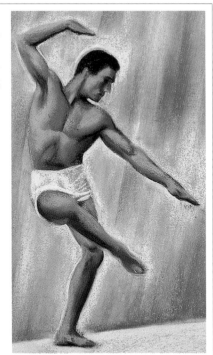

The warm quality of color typical of a tennis player is reflected in this palette, executed in oil.

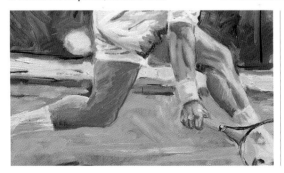

tone is created. It is common to use this type of mix for figures in motion under a cold light (for example, on a cloudy or rainy day, in partial darkness, or in an oblique light).

As we go deeper into the shadows, earthy and shade colors containing a bit of blue (a color that is always used in mixes for shadows) are used. As a result, the color of shadow is always colder than that of illuminated areas.

include a little bit of blue come into play; blue always is used in mixtures for shadows. As a result, the color of shadows is always colder than the colors in a lighted or illuminated area.

Cold Flesh Tones

When cold colors are used in mixes, such as green and blues, almost always mixed with lots of white, a cold flesh

Acrylics make it possible to use a cold palette for flesh tones.

SLIGHT MOVEMENT

With slight movements, the softness of the profiles and the inner lines is easy
to see. With respect to shading and coloring, gentle gradations are needed
to communicate shapes.

Characteristics

Many movements involve only a part of the figure, but the attitude of the entire person has to be coherent with that action. With moderate movements, you can use a model in a fixed pose that is set up to reproduce the coherence that the action demands. Afterward, you can endow the parts in motion with the additional details that didn't appear in the live model. This is done based on the techniques appropriate to the medium chosen for the project.

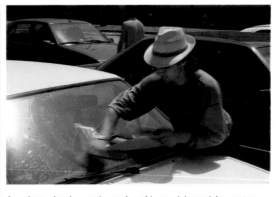

In order to sketch an action such as this one, it is crucial to capture the general leaning of the figure over the windshield.

MORE ON THIS TOPIC

• Moderate Movement **p. 74**

Daily Activities

There are a countless number of actions made up of slight movements in just part of the figure. This may amount to pouring milk into a cup, putting an article of clothing onto a coat rack, putting some food into the refrigerator, turning off the burners of a stove, eating, and so forth.

Study the part that is in motion and do the sketches necessary to master the depiction of the action.

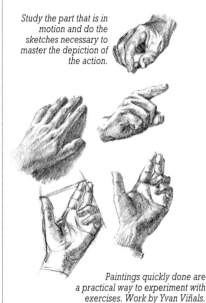

Paintings quickly done are a practical way to experiment with exercises. Work by Yvan Viñals.

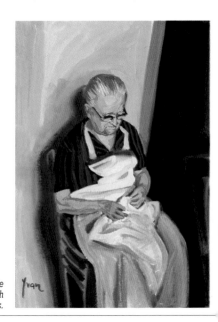

Grasping Objects and Maintaining the Action

The problems of drawing and representing a shape are connected to the outline of the hand that is grasping the object and the color and tonal valuation being analyzed.

To undertake a drawing or a painting of a figure in motion, it is a good idea to start with a moderate action, mostly because it may be possible to work from a live model. In this case, you can start with a tonal outline that sets up the various important areas with different tonal values in order to organize the color structure.

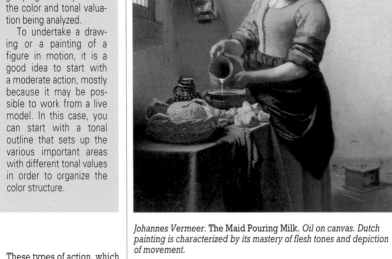

Johannes Vermeer. The Maid Pouring Milk. Oil on canvas. Dutch painting is characterized by its mastery of flesh tones and depiction of movement.

These types of action, which do not require much effort, do not entail any increase in the size of the muscles, and the muscular tension is negligible.

In the absence of bulges, the skin presents colors and tones that blend gently from lighter to darker and vice versa. As a result, the color and tonal values that need to be represented involve gentle gradations.

Naturalness

Sometimes a natural gesture is created simply in the fingers of the hand that performs the action. The concentration depicted in the facial features is part of the explanation. The inclination of the body over the work or the action being carried out lends credence to the gesture.

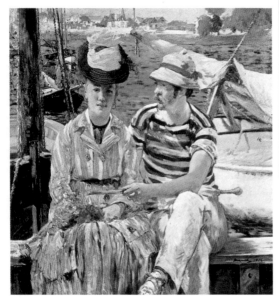

In the famous work Argenteuil *by Edouard Manet, the simple hand gesture makes this scene appear totally natural.*

TECHNIQUE AND PRACTICE

MODERATE MOVEMENT

When the motion involves the entire figure but doesn't constitute a strenuous movement, it is said to be a moderate one. The most common example is the position assumed by a person walking. In such cases, the depictions of the figures require subtle shading to express volume.

Common Movements

The most common types of movement, such as walking, involve a great complexity of foreshortenings and gestures. Creating the outlines using line or brush is intended to communicate this movement. The proper shading and coloring are of crucial importance in conveying shapes without introducing any aberrations.

Combined Actions

A figure walking may be engaged in other actions at the same time. If this involves carrying some object, the mobility of the limb that holds the object has to be added to the action of walking. Depending on the extra effort that this act of carrying involves, the entire body may be affected. Therefore, coordination between the actions and movements in all parts of the figure is crucial and must be taken into account.

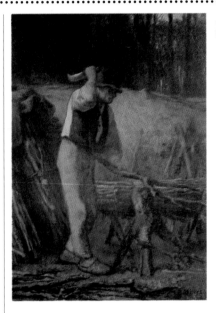

Jean François Millet. The Tree Cutter. Oil on canvas.

About Flesh Tones

From the instant that contracted muscles and active tendons become visible, the difficulty in creating accurate flesh tones becomes an issue.

The Method Is Always the Same

In order to communicate shapes, the method is always the same: the system of tonal valuation. Still, depending on the type of movement that the figure is engaged in, the distribution of the tones is different, since it all depends on the tones taken on by the muscles and tendons that are contracted. In confronting this greater complexity in assigning tonal values, the artist is continually guided by the light and the location of the most prominent parts in the proper perspective.

A quick pastel sketch allows capturing the essence of an entire group of figures.

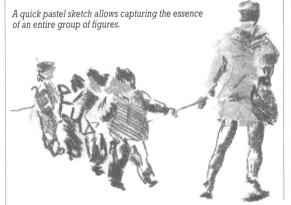

Pelliza de Volpedo. The Fourth Estate. This work depicts the advance of the workers along the road of progress. All the figures express the movement of walking toward the spectator. The folds in the clothing are sparse, and they explain the movement of each figure perfectly.

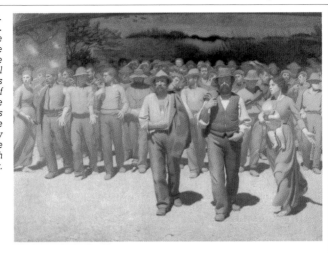

In an artist's early works, the difficulties that crop up can be seen in excessive contrasts. In an arm that is relaxed, for example, the shape is conveyed through a single grada-tion, as long as there are no contracted or easily visible muscles, in which case there has to be a gradation for each set of muscles. There has to be a smooth transition from one gradation to another in order to avoid the abruptness and excessive contrasts mentioned earlier.

Illustrations for scholastic books devote great attention to outlines in the basic drawing.

Watercolors are the medium that is frequently used for coloring.

In the illustration, watercolors are applied wet over dry to keep the new colors from mixing with a previous one. Despite the small size of the figures, the impression of volume is striking.

SPORTS

Not all sports involve violent movements, but when they are performed, the body arches and tenses, and muscles and tendons stand out. As a result, there are noticeable colors and tones, with greater contrasts among them.

Characteristic Movements

When we watch a sport being played, there is a series of mental images and postures that are associated with it in an almost intuitive fashion. If the sport develops part of the musculature, the imaginary figure should show that characteristic. If the sport involves jumping over hurdles, the most accurate representation shows the position of the legs and the lean of the upper body at the instant the obstacle is cleared. A graceful body is generally attributed to a speed or figure skater, or an athlete doing floor exercises.

In observing a group of athletes, it is very easy to recognize the characteristics of the movement that they are carrying out. A photo also allows capturing the form that the muscles take on when they are called into play. For comparing the posture of one person or another, you can identify the individual who best represents the form of the sport in question.

Rough sketches are useful in locating the muscles and tendons that contract with the movement. The arrows indicate the directions of the brush or pencil strokes in conveying volume.

Notice how the runners all have the same foot forward. Tall or short, husky or lean, they all display the same contraction in corresponding muscles. Athletes with the other foot forward would be the mirror image.

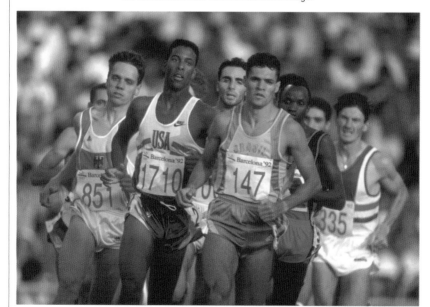

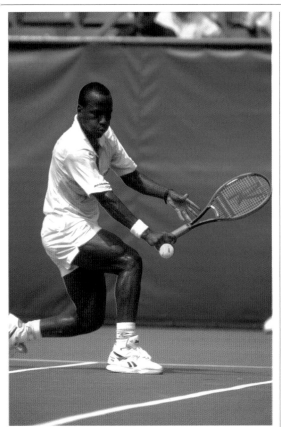

Braking against the ground to counteract the forward motion shows the contraction of the muscles and tendons.

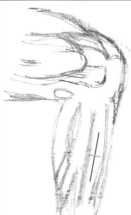

Sketches are used to practice creating the shapes of the muscles. In working on the canvas or the paper, the colors already have acquired a specific purpose with respect to length and breadth.

The sketch can include information on the shape and on color or tonal values.

The Prototype of the Athlete

Every sport is thus associated with a prototypical body. A sport that requires a more heavily muscled body, such as that of a gymnast who performs on the rings or the vaulting horse, presents more challenging inner lines and contrasts between colors and tones than we can adequately represent with the hollows created by the contraction of the tendons and muscles in action.

Even though gradations are still the ideal technique for depicting flesh tones, they have to be adjusted to the characteristics of every type of muscle.

Some physical manifestations of great, sustained efforts, such as the formation of drops of sweat, are also captured in paint by means of appropriate coloring and representations of shine and reflected light.

MORE ON THIS TOPIC

- Inner Lines **p. 36**
- The Physical Expression of Exertion **p. 48**
- Muscles in Action **p. 50**

The Surroundings

A sport involves surroundings that are peculiar to it and that include colors and shapes that become part of the artist's work in drawing or painting. The palette plays with the ambient colors reflected in the athlete's body.

CLOTHING

Figures show only the part of their skin that is not covered by clothing; in order to represent the skin, the artist calls on the palette of flesh tones. With respect to the clothing, all the tones of the actual reflected and ambient colors are created.

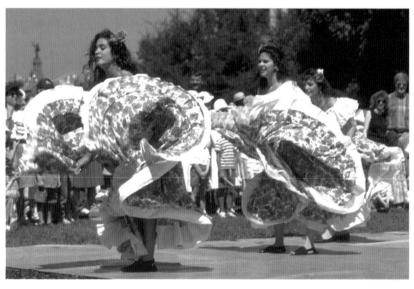

How do we account for the flowing skirts of the dancers?

Clothing in General

The most important aspects of clothing are the way it hangs and the type of folds or wrinkles that form. The characteristics of the clothing that covers the body are such that it reveals the movement in the figure. For example, a stretchy article of clothing, such as a leotard for floor exercise, or cycling shorts, molds to the body and grips it. A loose T-shirt, on the other hand, clearly shows the body parts inside it, while the rest of

the garment flies in the wake of the movement executed by the figure—in a race, for example.

The folds in the clothing are the result of various factors, such as the stiffness of the fabric and the influence of the body (armpit, elbow, knee, loins, bottom of the buttocks, and so forth).

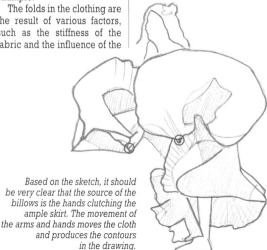

Based on the sketch, it should be very clear that the source of the billows is the hands clutching the ample skirt. The movement of the arms and hands moves the cloth and produces the contours in the drawing.

MORE ON THIS TOPIC

- Describing Movement **p. 40**
- Slight Movement **p. 72**
- Moderate Movement **p. 74**

In a less spectacular manner, the skirt of a figure twirling around also displays a set of folds and the person's movement.

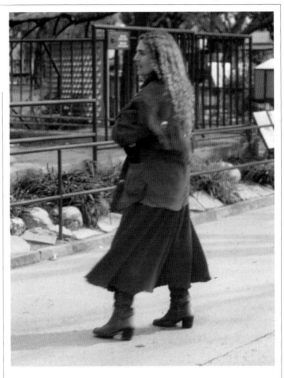

Objects and Movement

Both the clothing and the footwear worn by the figure in motion have to be depicted in a consistent manner. If a tennis player is holding the racket by the handle, the foreshortening of the racket has to correspond to the hand action, with the right pressure and relevant wrist action. Continuing with this example, the foot covered by the shoe flat on the court and the leg display the braking motion. Still, during the running or walking movement, the shoe in contact with the ground can display flexion that corresponds to the phalanges that are providing the forward impulse and the push off.

Sports Clothing

Modern sports clothing has special characteristics. Syn-thetic materials offer many different sheens and reflections. This is true of both tight and loose-fitting garments.

Even the types of wrinkles and folds that appear in sports clothing are influenced by the artificial fibers from which they are made.

Shoes

Most sports activities involve shoes that are specifically designed for that use. The shape and color of the shoes, as well as their flexibility and their traction, are factors that need to be taken into account.

It is not essential to include all the folds of the skirt in the sketch. Draw the most important ones, and use the best direction for describing the movement.

Brush strokes in acrylics are used to express the movement and billowing of the skirt.

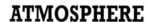

ATMOSPHERE

The palette is used to develop flesh tones and all the colors and tones of the clothing, and this work continues with the treatment of the background. Working on the atmosphere that surrounds the figure is as important as creating the figure itself, and it depends on the contrast that is created. The background is colored in less concretely than the figure.

The Figure and the Background

Sometimes a figure is painted or drawn without any background; this often involves quick sketches or complete works intended for advertising. Still, a finished work usually requires a background for the figure in motion.

An Analysis of the Background

The shapes and colors that appear around the figure in motion are important because of the contrast that they present with the shapes and colors of the body and the clothing. Since the projects don't always involve a live model, the colors of the background are often imaginary; in that case they can be made to contrast or

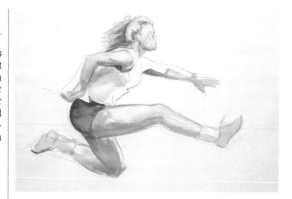

The figure stands out against a white background.

When the figure is surrounded by a textured background, the sense of depth is heightened. Watercolor by Myriam Ferron.

Specificity and Generality

A figure in motion is treated with specificity, and the background with generality. The mixtures and the creation of textures have different purposes in both cases. Specificity requires defined outlines, which are created through relevant contrasts. Generality, on the other hand, involves vaguely defined outlines that are created by juxtaposing colors that present minimal contrasts with one another. Even a luminous background should be done in a variety of colors.

harmonize with the colors of the figure.

Framing

What is the best framing for a figure in motion? The framing may involve the entire figure or just a part of it. The posture of the body can have a direct effect on the format chosen for the work. The background consists of all of the illustration that surrounds the figure—in general the upper part, even though a figure that is suspended in the air is completely surrounded by the background. The proportion between the background and the figure is particularly important.

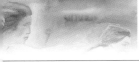

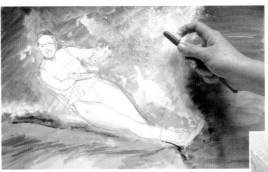

A gouache illustration can be started by coloring the background with very diluted paint.

Gouache permits subsequent coloring of the skier's figure with thicker paint to create effects of contrast.

Background Treatment

The way the background is treated, the texture and the colors used, can have a major effect on the finished illustration. With the exception of very realistic or super-realistic works, the background should be handled with less specificity and contrast than the foreground. This allows highlighting the figure in motion, and the shape is based on the resources that are used to make it stand out.

Because dense gouache is opaque, it completely covers the colors with rounded profiles that establish the desired shapes.

MORE ON THIS TOPIC

- Water As Background **p. 82**
- The Surface **p. 84**
- More About Surfaces **p. 86**
- Dramatizing **p. 94**

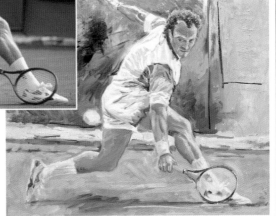

In depicting the background of this figure in motion, a sense of depth is created by interpreting reality through the use of colors that don't define specific forms, but which add great chromatic richness and produce an undeniable impact.

WATER AS BACKGROUND

At the ocean, the pool, or the river, water forms the background for the figure in motion. This requires us to develop a palette specifically for representing the colors of the water. In addition, the obvious effort in the figure in motion has characteristic connotations.

The Figure in Water

A human body in the water experiences buoyancy. This creates a lightness that results from reduction in the force of gravity. When the figure in motion is surrounded by water, it requires specific observation of the character- istic gestures that the body takes on when it is partially or totally submerged.

With respect to color, the work focuses on the part of the body that remains out of the water and the part that is submerged. The palette has to develop the mixes used to create the flesh tones of skin that is wet, the ones that are

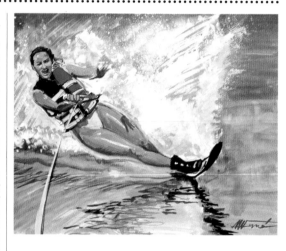

This gouache painting by Myriam Ferrón combines all the elements.

The figures are erect, and we can't see where the feet make contact, but the notable reflections on the water help explain the balance.

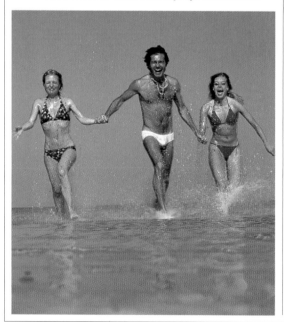

Glimmers and Reflections

There are lots of shiny areas and reflections on wet skin, similar to what happens on water. The many chromatic possibili- ties of this phenomenon require establishing a way for selecting the aspects that this repre- sents. First, you note the most important shines and reflections, and ig- nore the others. The ones that are to be included in the illustration are accen- tuated to the maximum. This avoids a motley appearance and cements things, preserving what is important without taking away from the figure.

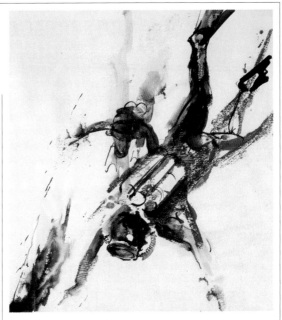

Vicenç Ballestar uses ink in this portrayal of the diver's weightlessness.

seen in transparency through the water, and the reflections that the upper parts of the body create on the water's surface.

To all this we have to add the characteristics of the water itself—its own movement and that imparted to it by the figure: in the ocean there are waves and foam, spray, one color for the bottom and another for the water; a swimming pool has a color and movement in the water; and the torrent of a mountain river displays turbulence due to the current and submerged rocks.

Weightlessness, Impulsion, and Inertia

The effects experienced by a submerged body are felt in all the movements that it makes. The type of impulsion that can be created by kicking the legs in and out of the water is very particular, as is the resulting fall of the water. This context should be suggested by the drawing and the sketch right from the beginning.

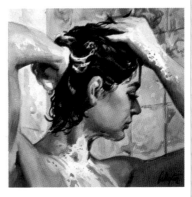

Watercolors are a very effective and immediate medium for capturing the effects of suds and reflections on the nude figure. Work by Vicenç Ballestar.

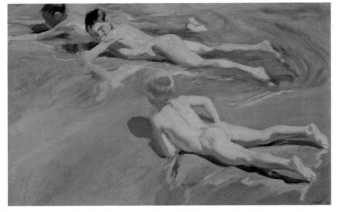

Joaquin Sorolla y Bastida. Children on the Beach. *Oil on canvas. This work highlights the pictorial possibilities that the reflections from wet skin produce on the flesh tones.*

THE SURFACE

Walking through the city, jogging in the mountains, and playing basketball on a court all involve surfaces specific to the surroundings. Painting and drawing need to express coherence in the contact and the characteristics of the surroundings.

Gravity

We have already seen how the force of gravity acts on a figure that is falling or touching a non-liquid surface. Still, there is a major difference between a dirt surface that absorbs shock and a wooden or concrete floor, which produce a very hard impact. The figure in motion adapts to each case. The soft parts of the figure and the loose clothing move upward or downward depending on the jumping movement or the inertia of the fall.

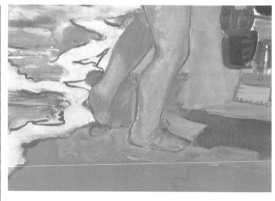

When walking on sand, the feet sink in and the configuration of the joints is different.

On the Ground

A figure running in the mud, on well-trodden ground, or on a dry and dusty road shows different types of effort. Each case presents a different scenario. As such, each circumstance must not escape the sharp eye of the artist, who has to take in each image in its entirety.

MORE ON THIS TOPIC

• Atmosphere **p. 80**

Practice doing freehand sketches to try out different foot positions. The bare foot changes according to perspective, flexion, force, joints used, and so forth.

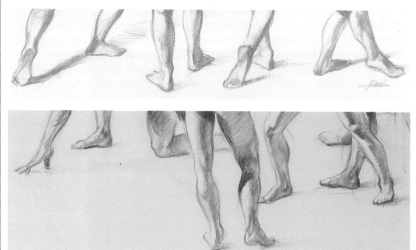

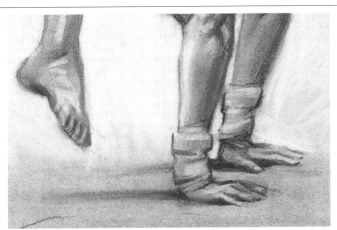

If the feet aren't in contact with the surface, the hands may be.

Shadows

The existence of a shadow is very important in a representation; it contributes chromatic richness and makes it possible to convey depth in the work. The qualities of light and shadow depend on the nature of the surface onto which the shadow is cast and on the characteristics of the figure; the quality of the light in the scene also has an effect. They are mixes that darken the color of the ground, and that are influenced by reflections and nuances from the surrounding colors.

The direction in which a shadow is projected depends on the location of the light source; it is an indication of one possible direction for applying the color that makes up the shadow. The other direction could be horizontal.

A foot sheathed in a ballet slipper contacts the floor only at the point of the toe. In this case, the important factor is the complete extension of the foot and the direction it indicates.

At the instant when the arms come into play, a swimmer's feet are perfectly positioned on the diving board.

MORE ABOUT SURFACES

The type of light influences the flesh tones of a figure in motion and the surroundings. This is verified by studying and comparing different surfaces, surroundings, and types of light—artificial or natural—until you can quantify their characteristics.

Natural and Artificial Light

The quality of natural and artificial light presents different color characteristics; in addition, cast shadows depend on the location of the natural light source, or the possible sources of artificial light. In a soccer game played at night and broadcast on television, you can see that there are shadows at the feet of the players. Every one of them corresponds to the most influential source of artificial light close to the player.

Reflection on the Playing Surface

The characteristics of the surface on which the figure is moving may produce a number of reflections of the ambient light. For example, in addition to a cast shadow, the parquet floor of a basketball or handball court has a highly reflective capacity that the artist needs to take into account through the reflection of the figure in motion.

Ice

In skating and ice hockey, the surface has a very strong reflective power. What is the outline of the reflection like? Although it is a little distorted by the imperfections in the surface and by the movement itself, the reflected image is inverted. There is an obvious symmetry between the figure and the reflection on the surface.

Reflections

The strongest points of light perceived in reflections are the shiny areas; they require a special treatment no matter what medium is used.

Texture

In order to represent a flat surface, we have to establish the rhythm of the best brush strokes for an accurate representation, whether we are working in oils or acrylics. For example, the marks from the palette knife in an initial approximation tend to the horizontal, or represent one of the directions of the receding lines (in an oblique or aerial perspective). In a second coat, one of the other receding lines is used. The resulting texture is very descriptive of the surface, the cast shadows, and the reflections.

With watercolors, for example, the shine is represented by the white of the paper.

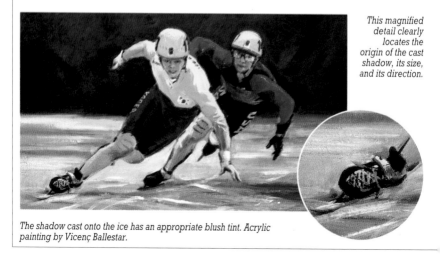

This magnified detail clearly locates the origin of the cast shadow, its size, and its direction.

The shadow cast onto the ice has an appropriate blush tint. Acrylic painting by Vicenç Ballestar.

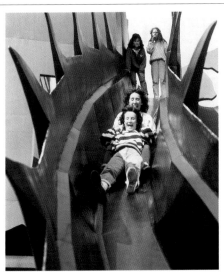

Any reflecting surface, such as this metal slide, can be an interesting setting because of the potential of the shine and the reflections that they bring to the composition.

Different shades of color are used in the reflections depending on the clothing that the figures are wearing. The most important ones can be selected for use in the illustration.

Characteristics of Reflections

Reflections are not entirely uniform. The richness of color in the depiction of a reflection depends on the artist's powers of observation and synthesis of the phenomenon. But it is clear that this involves an element with great visual potential for the background and the surroundings of any figure in motion.

<div>

MORE ON THIS TOPIC

- Atmosphere **p. 80**
- The Surface **p. 84**
- Interpretation **p. 92**

</div>

The direction of the lines done with a marker suggests the possibilities for the setting, with the obvious intention of highlighting them.

COMMON OBJECTS

In addition to the clothing that the figure wears in performing a movement, there are also many objects that may accompany the action. In drawing and painting any of these objects, we have to respect the foreshortening that is appropriate to the gesture.

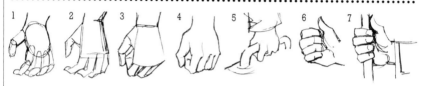

You can practice doing sketches of hands holding everyday items: 1 and 2) the sketches can be based on circular and cylindrical shapes; 3, 4, and 5) the hand grasping the handle of a suitcase; 6 and 7) the hand holding a bar in a bus.

The Hand That Grasps

The hand that holds an object (a tennis racket, a vaulting pole, or a ball) embodies the gesture, the exertion, and the movement that are transmitted to the object.

The object and the movement of the figure form a completely harmonious whole. A drawing that does not observe this cohesiveness will appear forced or awkward.

The Vehicle

A motorist, a mounted rider, a cyclist, and others depend on the speed of their vehicle at any given instant. Acceleration involves maintaining balance, and the bicycle or motorcycle would be totally unstable if it weren't kept up to adequate speed. The foreshortening of the figure in motion demonstrates this type of balance, and the snapshot of the movement in the person-vehicle unit can create great kinetic interest in the work.

Frederick Remington. Cavalry Charge on the Southern Plains. *Oil. There is total cohesion of movement between the rider and his horse.*

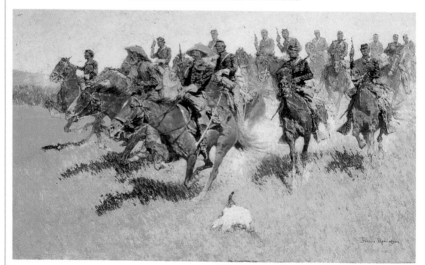

Miquel Ferron has done a drawing for airbrushing with a certain amount of synthesis, adjusting the subject to the detail.

More or Less Pressure

The pressure used in holding an object can be read in the knuckles and the strain in the muscles and tendons of the fingers. The direction of the thumb and its grip control the movement of the object. The lines and brush strokes have to be very descriptive to express the nature of this pressure. On the one hand, there is the rhythm for depicting the surface of the object, and in contrast, the rhythm that conveys the shape of the hand. In drawing, crosshatching is used; in painting, the texture is produced by applying layer on layer with deliberate direction in the brush strokes.

Acceleration and Setting

With a figure in a vehicle in motion, the acceleration is emphasized. When the attention is fixed on the figure and the vehicle, the background appears blurred, and the shapes are distorted. This dynamism is commonly represented by stretching in the direction of movement.

MORE ON THIS TOPIC

• Continuous Motion **p. 42**
• Muscles in Action **p. 50**
• Quick Sketches **p. 56**

Note the hand on the grip, the foot on the pedal, and the lean of the body to the right to stay in balance.

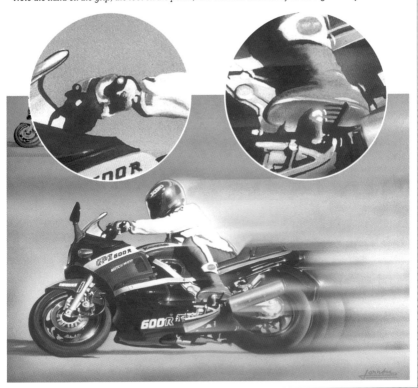

OBJECTS IN MOTION

The figure in motion carries certain objects with it that likewise take on movement. Each object shows its stiffness or flexibility. The object is depicted with artistic strokes as early as the preliminary sketch, where even its texture is included.

Position and Movement

Depending on the point of view and the instant of movement, the object takes on a specific shape. With a fairly flexible object, such as rubber boots, there is a change of shape that indicates the pressure of the shin and the instep at the beginning of a stride.

What is the visual interest or the implication for movement in an individual who is wearing a backpack? Perhaps one of the nylon straps is loose and trailing behind the person. The pack has to look as if it is loaded and sagging from the weight, yet it conforms perfectly to the person's back, held by a hand, a shoulder, or both.

Another example is a figure that is running while wearing a cap or a flexible hat: all the outlines of the cap or hat reveal the effects of wind resistance.

Objects in Perspective

The perspective of an object in motion is a good deal more complex than in a still life. With an immobile object the perspective can be established in accordance with the plane or the surface on which it rests. An object in motion

requires perfect orientation in space and must be situated properly.

As always, the process involves creating a framework that represents the object in perspective. This requires finding the most appropriate way to frame the illustration. We must remember that this

Let's take the example of a person who is wearing rubber boots while walking.

Here's a drawing based on the shapes of the boots as the person walks.

The color completes the representation of this type of footwear.

sketch is what establishes the proper proportions between the figure and the object. In the case of a person riding a bicycle, the height of the bicycle has to be adjusted to the height at which the head is located.

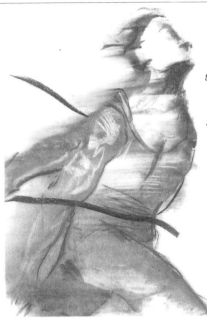

Using an individualized, abstract style, Ramon de Jesus conveys movement through the shirt and the pants, which are represented in perspective and in accordance with their characteristics.

MORE ON THIS TOPIC

- Slight Movement **p. 72**
- Moderate Movement **p. 74**
- Common Objects **p. 88**

The perspective of the bicycle has to show the lean used in maintaining balance. The helmet, which is not level on the head, inclines in a different direction. Drawing by Vicenç Ballestar.

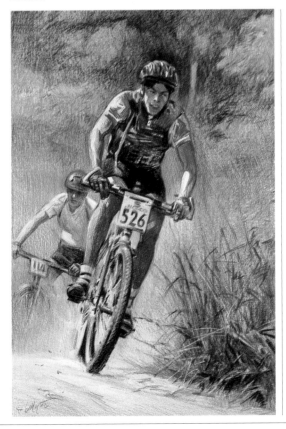

Coherence Between Object and Figure

There must be complete coherence between the two. In addition to communicating the type of action the figure imparts to the object, the artist has to preserve accurate proportions; for example, an oar can be of varying lengths, but the support points as it enters the water have to convey the applicable relationships, the weight, the effort, and balance, and effectiveness of the action.

A study of proportions needs to relate the size of the figure to that of the object and adjust them both in the proper perspective. The law of larger/closer, smaller/farther applies, but the specific differences still require careful study. An excessively large object in the foreground can make the figure behind it look ridiculous.

INTERPRETATION

The figure in motion is a theme that is subject to interpretation,
especially when no photographic documentation is used. The artist in no way
feels bound by the corset of realism, and can create with total freedom.

Emphasis on Conveying Motion

A very realistic work is guided mostly by what the artist sees, but the version can dramatize the motion, exalt it, and highlight it. In these cases, even the shapes of the figure can become abstracted. The degree of abstraction produces a whole gamut of interpretations.

This interpretation can extend to both color and shape. Painters who work diligently with the human figure can produce truly original creations in color that depart radically from the model, the surroundings, and the figure in motion.

Visual Language

Interpretation involves going beyond the reproduction of a scene that expresses something by itself.

Artists who create their own version of a real scene, changing colors and shapes, idealizing or cutting out certain movements, are introducing their own interpretations of the theme.

The recognizable shapes and colors involve a visual language that provokes a series of sensations and feelings.

The Artist's Sensitivity

Depicting a figure in motion involves a large measure of interpretation on the artist's part, and that in turn is a function of two considerations: the degree of abstraction in

MORE ON THIS TOPIC

• Silhouette and Color **p. 34**
• Quick Sketches **p. 56**
• Dramatizing **p. 94**

Jean-François Millet. The Gleaners. *Oil on canvas. One of the essential traits of this work is the harmony of the palette.*

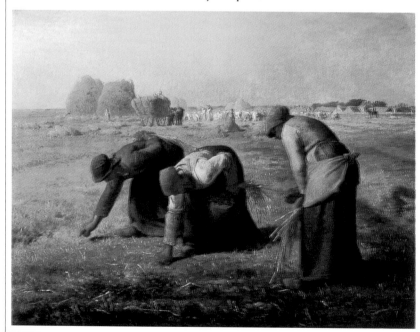

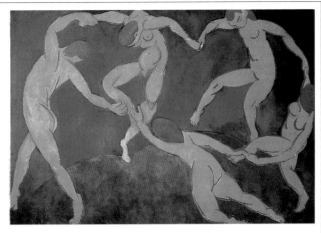

Henri Matisse. The Dance. Oil on canvas. The dramatization is applied to two aspects of the work: shapes and colors.

the vision of the movement, and the individual application of techniques and color afforded by the medium.

The delicacy of the chromatic treatment and the textures can endow a work with unequaled beauty, the result of the artist's sensitivity and good taste.

Purpose and Style

Interpretation fulfills a very important role in creating paintings and drawings that are done in a certain style, as with the proportions used in the field of illustration.

It is the line that establishes the greatest emphasis in the features, which may even take on the appearance of caricature. Still, although the most commonly used mediums in illustration are watercolors and gouache, even oils can be used to create the best style for the same purpose.

Norman Rockwell. Artist in Front of a Blank Canvas. Oil. This illustration was done for the magazine indicated in the image.

DRAMATIZING

The ways to add drama to an illustration are rooted in the selection of the framing; they also include manipulating stroke and line, using color contrasts, and creating suggestive and creative textures. The direction of the strokes and the textures in the colors constitute a type of rhythm.

Framing

The possibilities for dramatizing through the selection of the framing are centered on the use of the foreground. The figure doesn't even need to be complete; that way the size of the main part in the foreground increases in proportion to the background. The selection of an aerial point of view, whether high or low, also lends dynamism to the movement.

MORE ON THIS TOPIC

- Pastels **p. 60**
- Oils **p. 62**
- Acrylics **p. 66**

Stroke and Line

The right use of line can highlight the profile of a figure in motion, its shape, or the inner lines. The difference between an approximation line, or between an uncertain one and an artistic one, is clear. The latter is done with a confident movement, conveying the appropriate intensity right from the beginning. When shading and coloring are done using crosshatching, the direction of the series of lines creates texture and dramatizes the shape.

In Search of Contrast

The color palette used by the artist to depict a figure in motion can heighten the contrast by juxtaposing colors that are directly complementary. If less obvious contrasts are sought, indirect complements are used, or one or two of the colors that will appear next to one another are attenuated by the addition of a little white.

Contrast in the overall color scheme can also be based on a controlled contrast between pure and mixed colors.

Brush Strokes

The marks left by the brush strokes can create similar

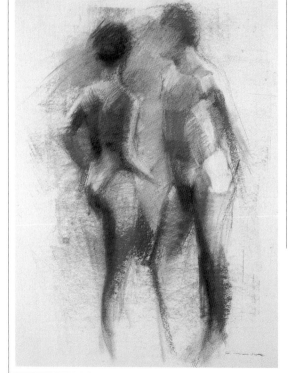

Pere Mon's way of working in pastels, with very indistinct profiles, creates an exaggerated appearance of flowing movement.

In coloring with pastels, the intent is to create distinct textures in the shirt, the skin, and the surroundings.

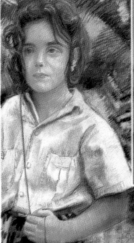

The final texture that J. Sabater has created in the shirt highlights the bare skin in the figure.

A particular texture can highlight the directionality established by the figure.

artistic effects in any medium where a brush is used, such as oils, watercolors, acrylics, and inks. That requires loosening up the wrist and playing with movement in the fingers that hold and guide the brush.

Texture: The texture that is visible in a work is created by a combination of lines, brush strokes, the application of one coat of paint over another, the techniques, and the tools used.

Rhythm: The correct repe-

tition of certain traits gives the work a rhythm.

Without overdoing it, in this instance the artist can highlight the shape of the figure and create contrast with the background.

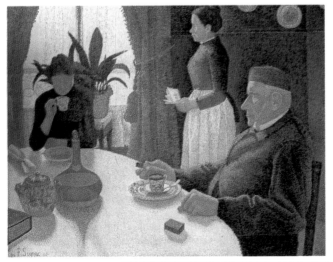

Paul Signac. The Lunch. Oil on canvas. In the post-impressionist period, Seurat and Signac gave rise to pointillism; this technique gives the impression that the figures are frozen, but it is still obvious that some of the subjects are moving.

All inquiries should be addressed to:
Barron's Educational Series, Inc.
250 Wireless Boulevard
Hauppauge, New York 11788
http://www.barronseduc.com

International Standard Book No. 0-7641-5358-7

Library of Congress Catalog Card No. 2001099154

Printed in Spain
9 8 7 6 5 4 3 2 1

Note: The titles that appear at the top of the odd-numbered
pages correspond to:

The previous chapter
The current chapter
The following chapter